Paisleys

Coloring for Everyone

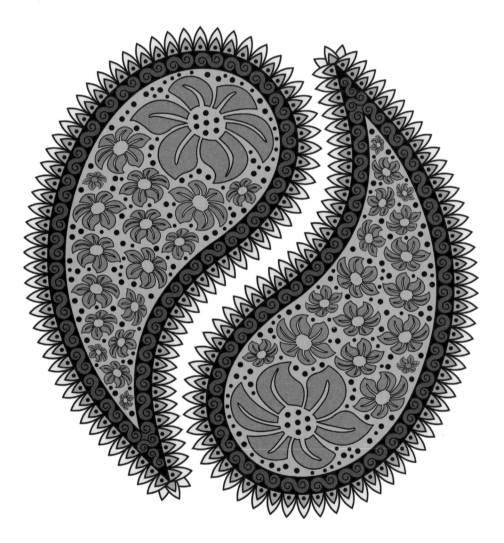

Skyhorse Publishing

Skyhorse Publishing books may be purchased in bulk at special discounts for sales promotion, corporate gifts, fund-raising, or educational purposes. Special editions can also be created to specifications. For details, contact the Special Sales Department, Skyhorse Publishing, 307 West 36th Street, 11th Floor, New York, NY 10018 or info@skyhorsepublishing.com.

Skyhorse® and Skyhorse Publishing® are registered trademarks of Skyhorse Publishing, Inc.®, a Delaware corporation.

Visit our website at www.skyhorsepublishing.com.

10 9 8 7 6

Library of Congress Cataloging-in-Publication Data is available on file.

Cover design by Owen Corrigan
Interior art edits and illustration by Abigail and Tim Lawrence
Text by Andres Dietz-Chavez

Print ISBN: 978-1-63220-650-3

Printed in the United States of America

Paisleys:
Coloring for Everyone

We all have fond memories of coloring when we were children, and even though we might be older, we still have that inner child who still finds joy in the activity. There are real benefits to coloring as we get older, as well. It can be a creative outlet, it can help relieve stress, and it can improve our hand-eye coordination. Let's not forget that we are creating something artistic and beautiful.

There are many mediums through which coloring can be explored, and coloring books are one of those ways. But many coloring books can be too simple for an adult, so we present to you a collection of paisley designs that offer more complex figures and shapes.

The striking paisley originated in ancient Persia, where it was called *boteh* or *buta*. The design's tear-like shape led to it being known as "Persian Pickles" by nineteenth-century Americans, as well as "Welsh Pears" once the design began to be produced in Scotland. The word "paisley" itself comes from the Scottish town of Paisley, which was one of the largest producers of textiles at the height of the design's Western popularity. It was during this time, in the eighteenth and nineteenth centuries, and spurred by the British East India Company's importation of Kashmiri shawls, that the paisley became synonymous with luxury.

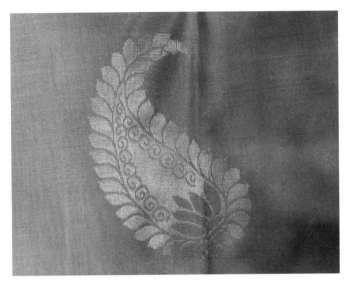

Mango paisley design in Kanchipuram silk saree (Arulraja)

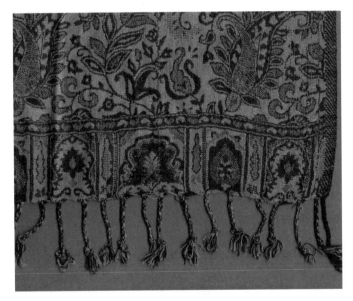

Detail of shawl with a woven paisley patterna woven paisley pattern (PKM)

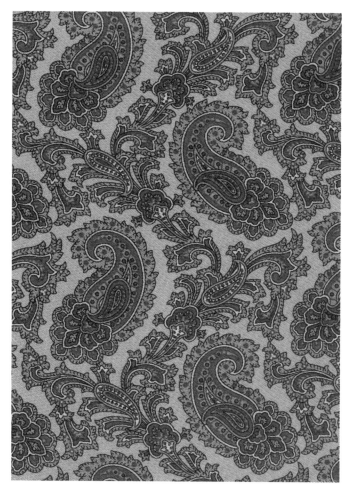

A modern paisley design (Makemake)

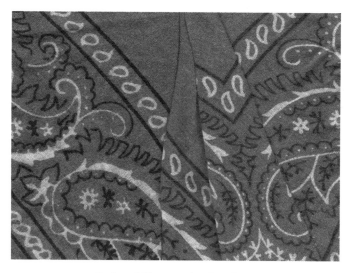

Red and blue paisley bandanas

Modern-day popularity of the design began during the Summer of Love in the late 1960s, fueled, in part, by the Beatles' adoption of the design after their pilgrimage to India. The design became closely tied to the counterculture movement, pairing well with the psychedelic lifestyle that many people assumed. Paisleys became even more closely tied with Rock 'N' Roll when the Fender guitar company began adding paisley wallpaper to some of their electric guitars. The musician Prince further strengthened the bond between music and the design by naming his recording label and music studio Paisley Parks.

The forty-six paisleys in this book are inspired by this rich history, and the designs have varying degrees of difficulty, from very easy to more complex. The first step in coloring is to select what you want to use for the coloring process. You may want to use crayons, colored pencils, or marking pens. You can use the blank stripes in the following pages to test your coloring medium, as well as color combinations. Make sure to explore whatever combination of colors you like. Pay attention to how you feel and try to find a corresponding color. Don't worry about what's right or wrong; allow yourself to associate freely and color accordingly.

In order to facilitate your creative freedom, the designs are printed on only one side of the page, and the pages are each perforated so they can be removed from the book to make coloring easier (as well as to allow you to use them as decorations). There are also colored examples of each of the designs in the front of the book to give you some ideas on color palettes and how to use them. The fun of coloring, though, is to use your own colors and inspirations, so allow yourself some creative freedom while coloring these wonderfully intricate designs. We hope you enjoy the designs included in this coloring book!

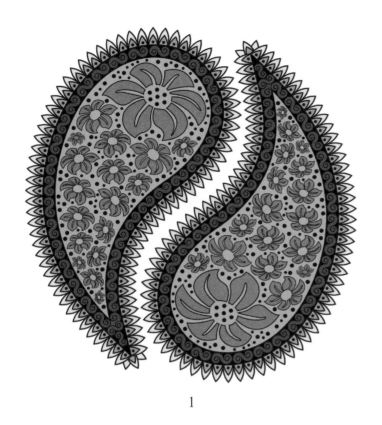

1

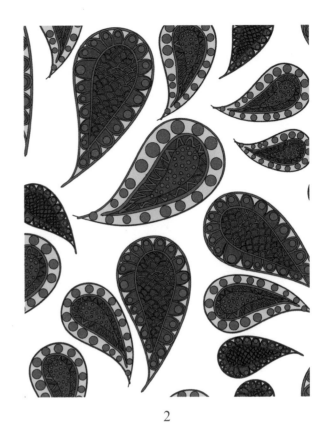

2

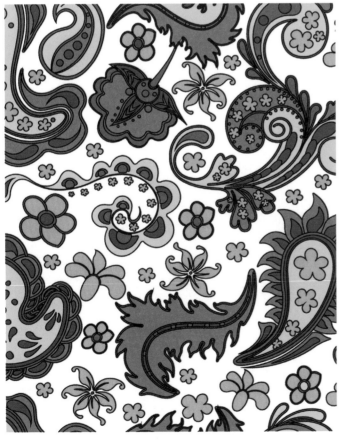

3

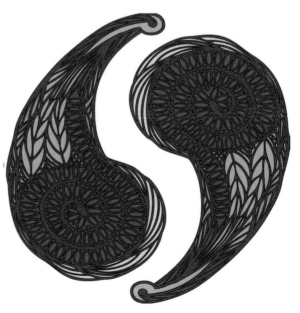

4

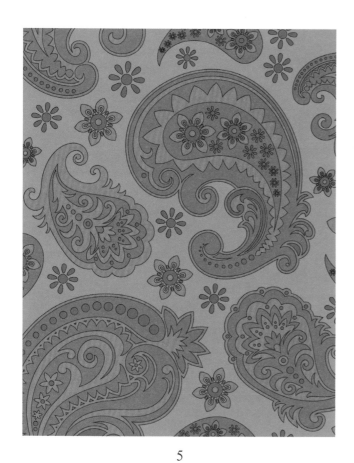

5

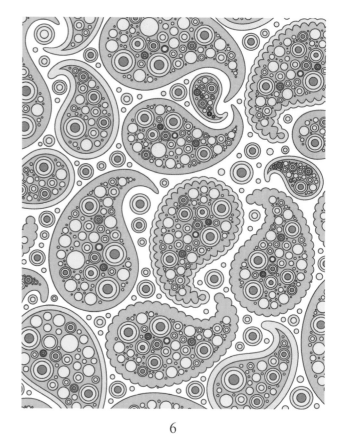

6

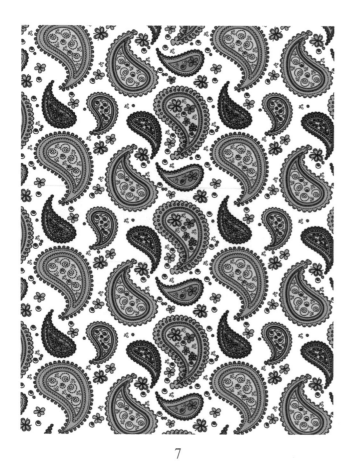

7

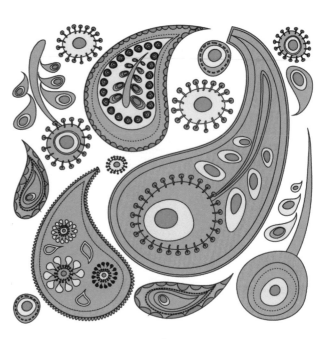

8

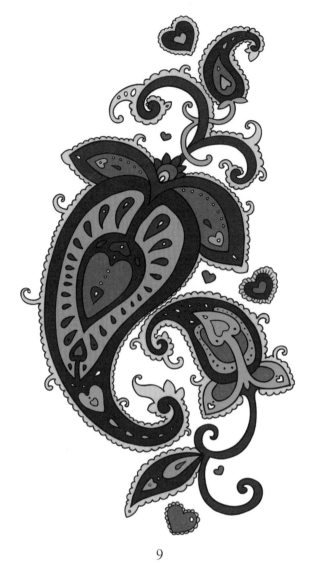

9

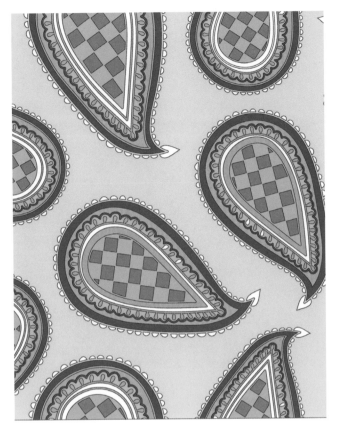

10

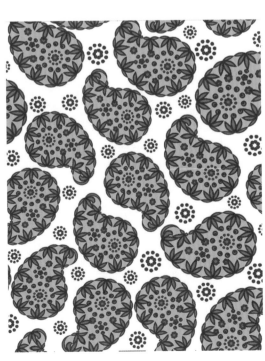

11

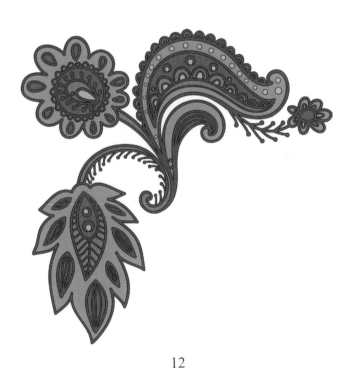

12

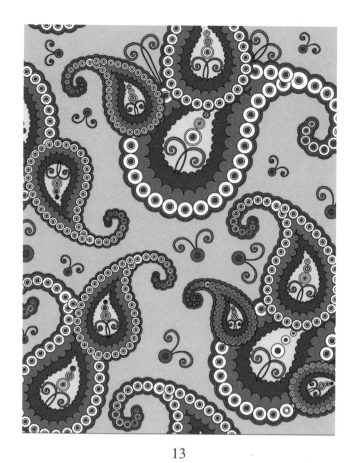

13

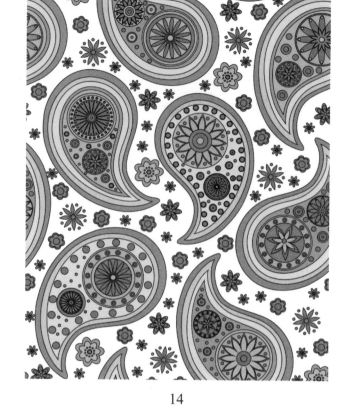

14

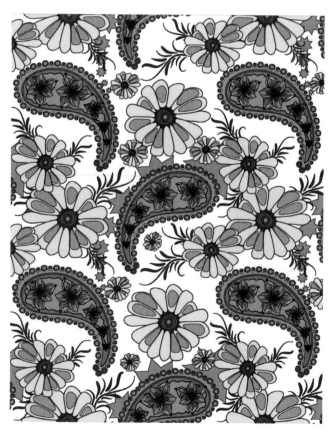

15

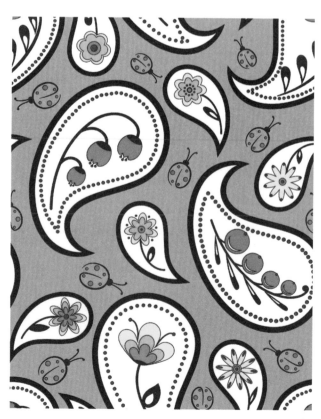

16

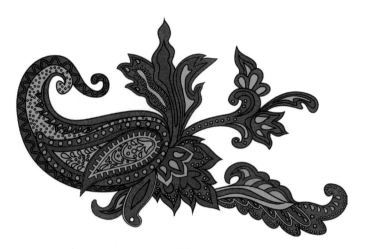

17

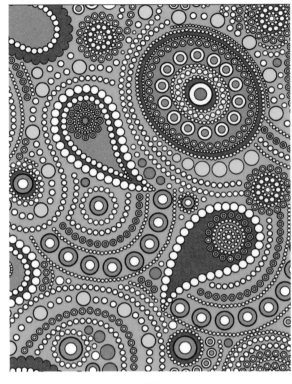

18

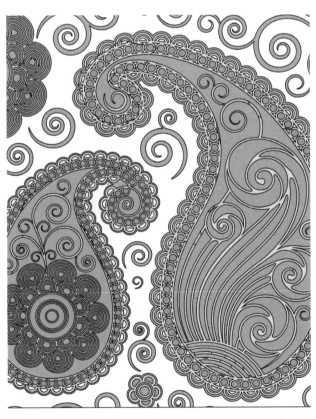

19

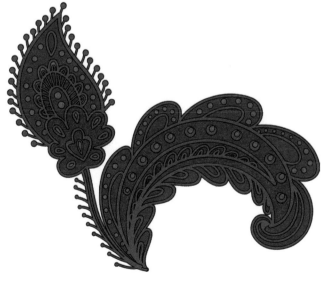

20

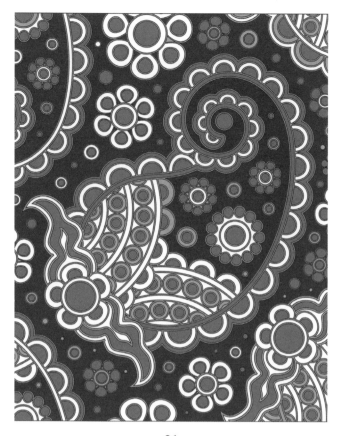

21

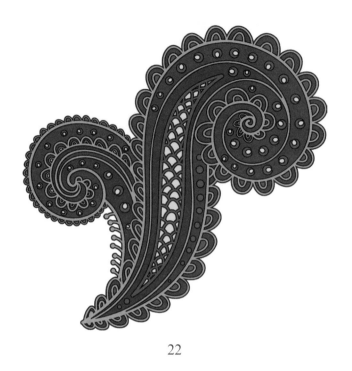

22

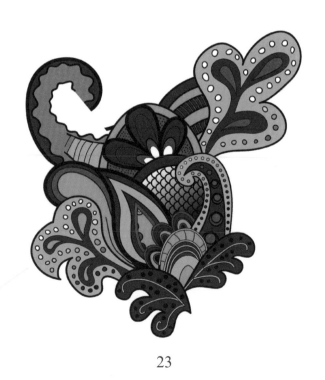

23

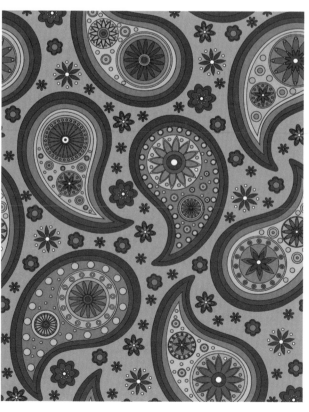

24

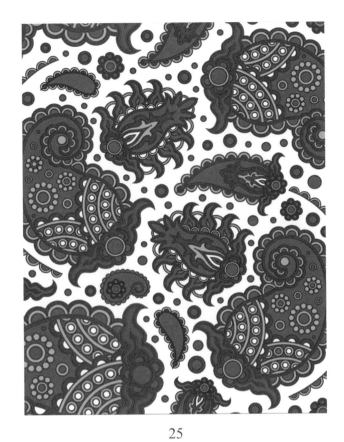

25

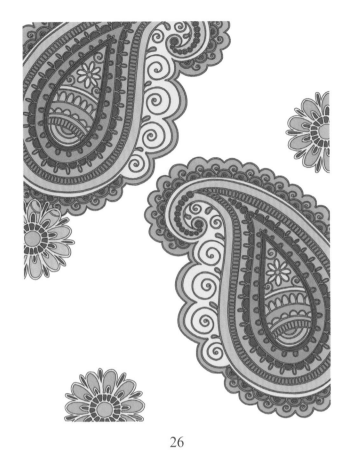

26

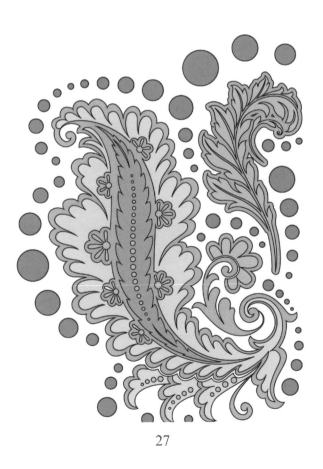

27

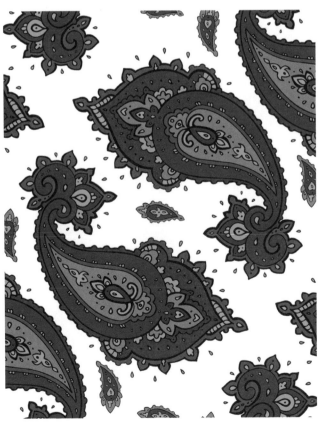

28

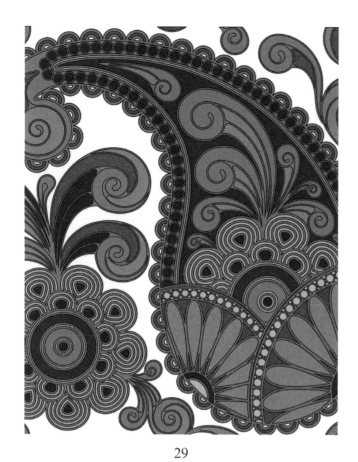

29

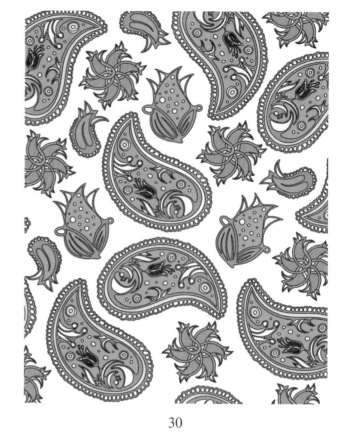

30

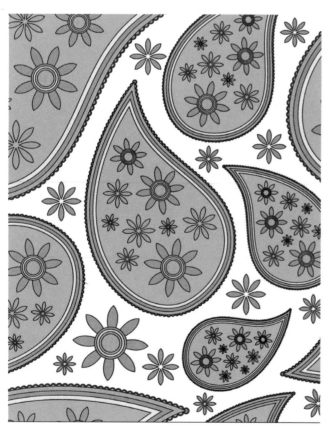

31

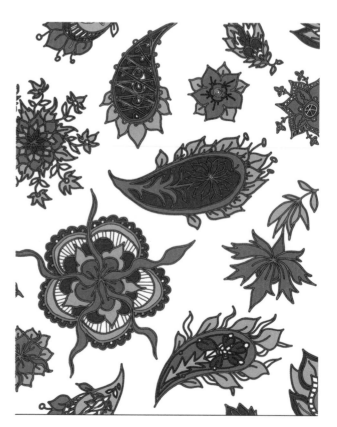

32

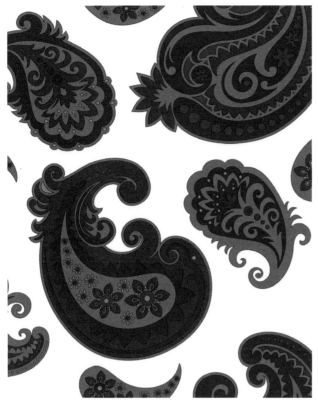

33

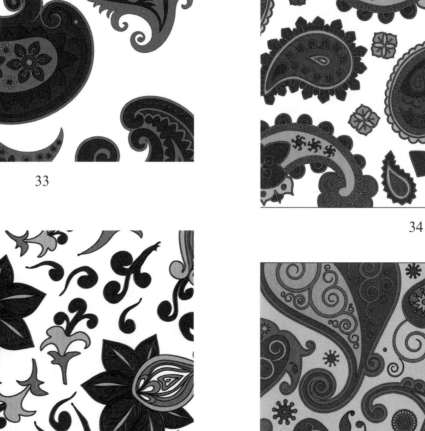

34

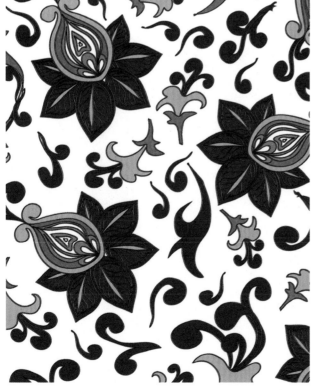

35

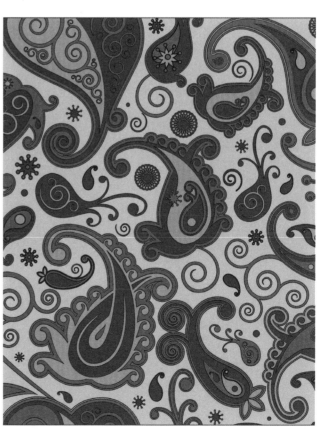

36

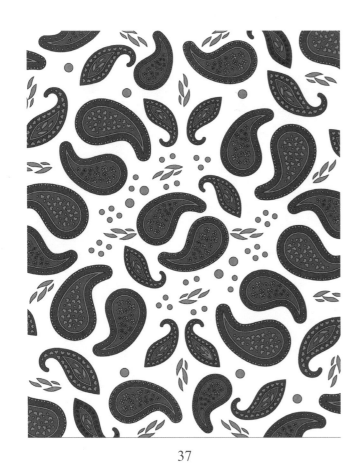

37

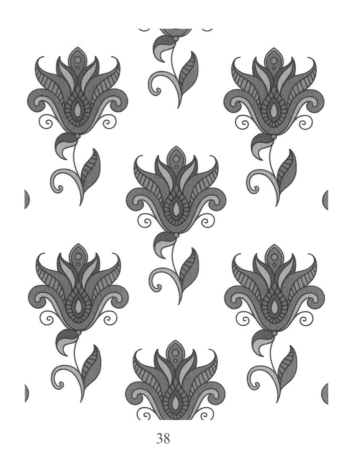

38

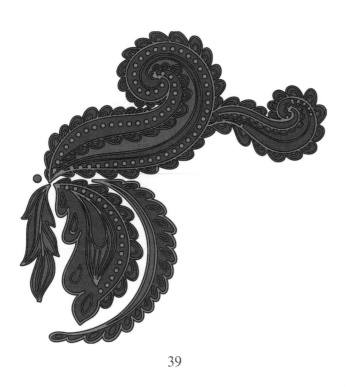

39

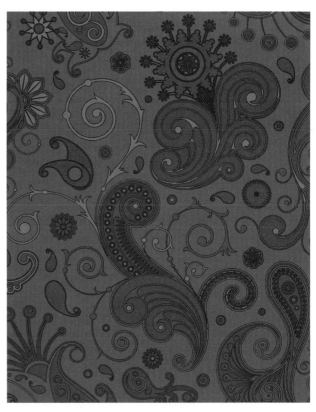

40

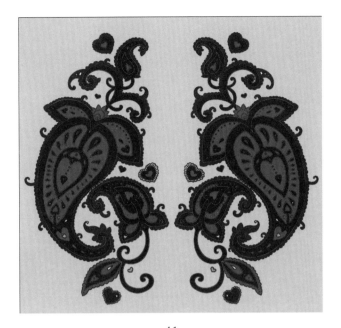

41

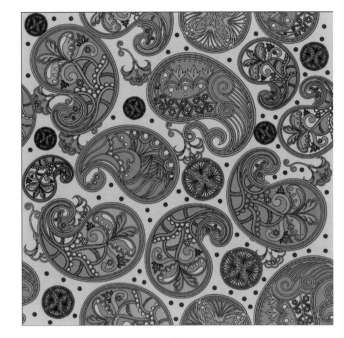

42

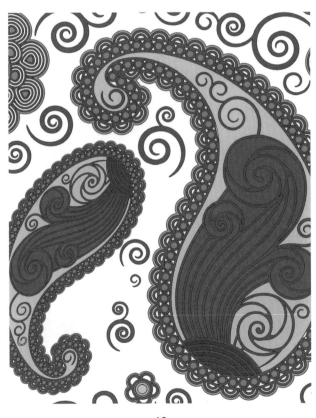

43

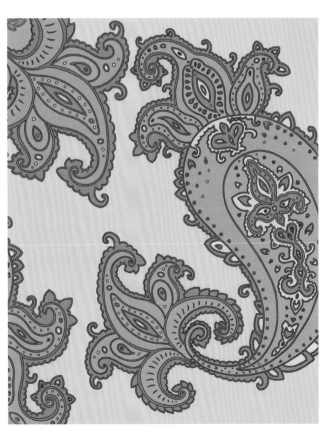

44

45

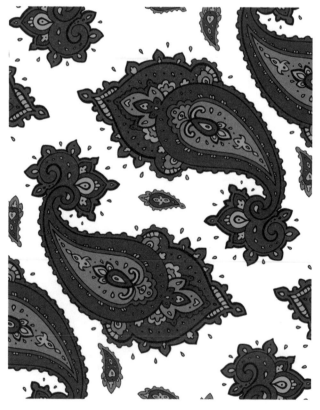

46

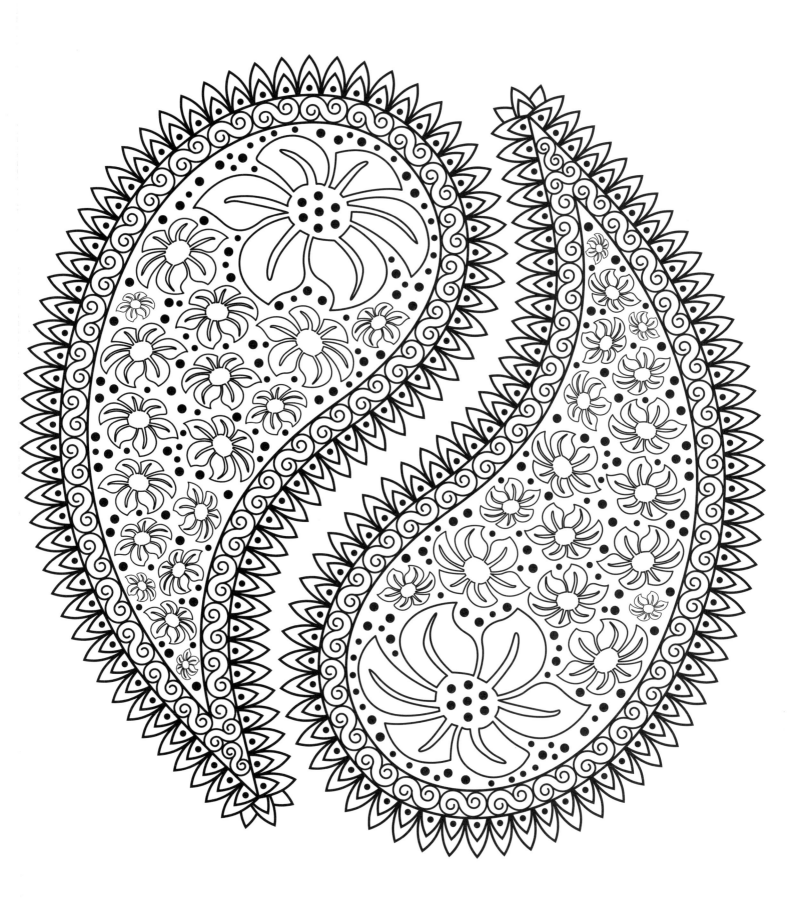

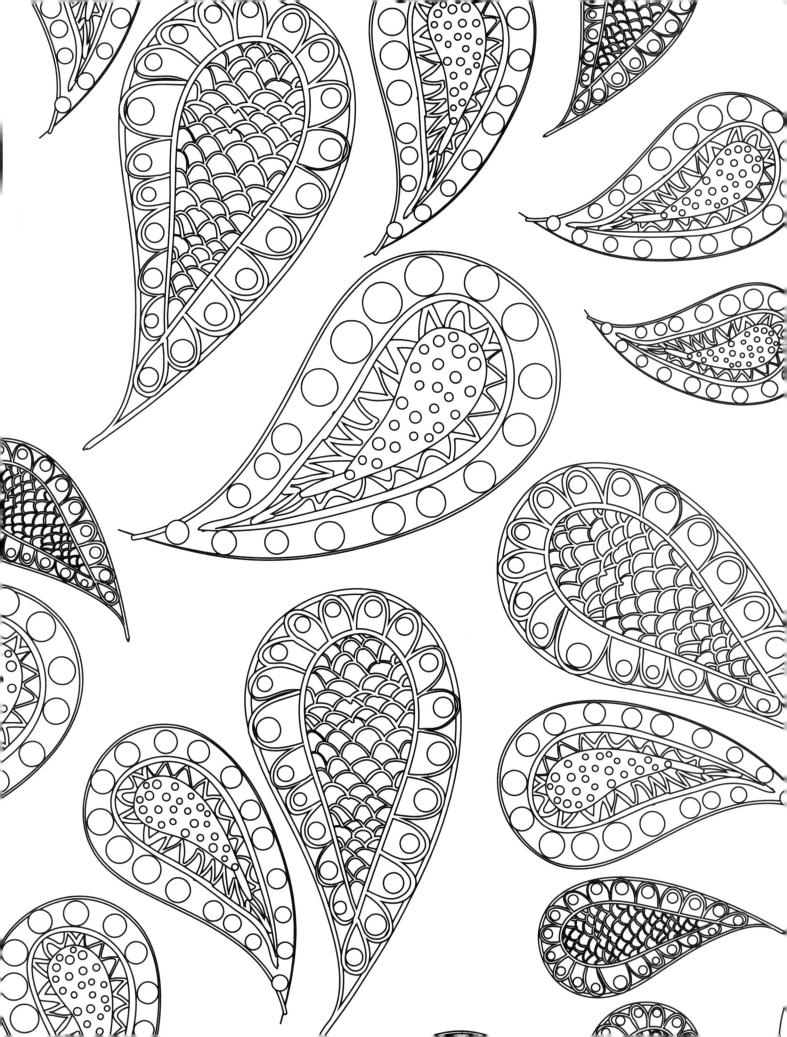

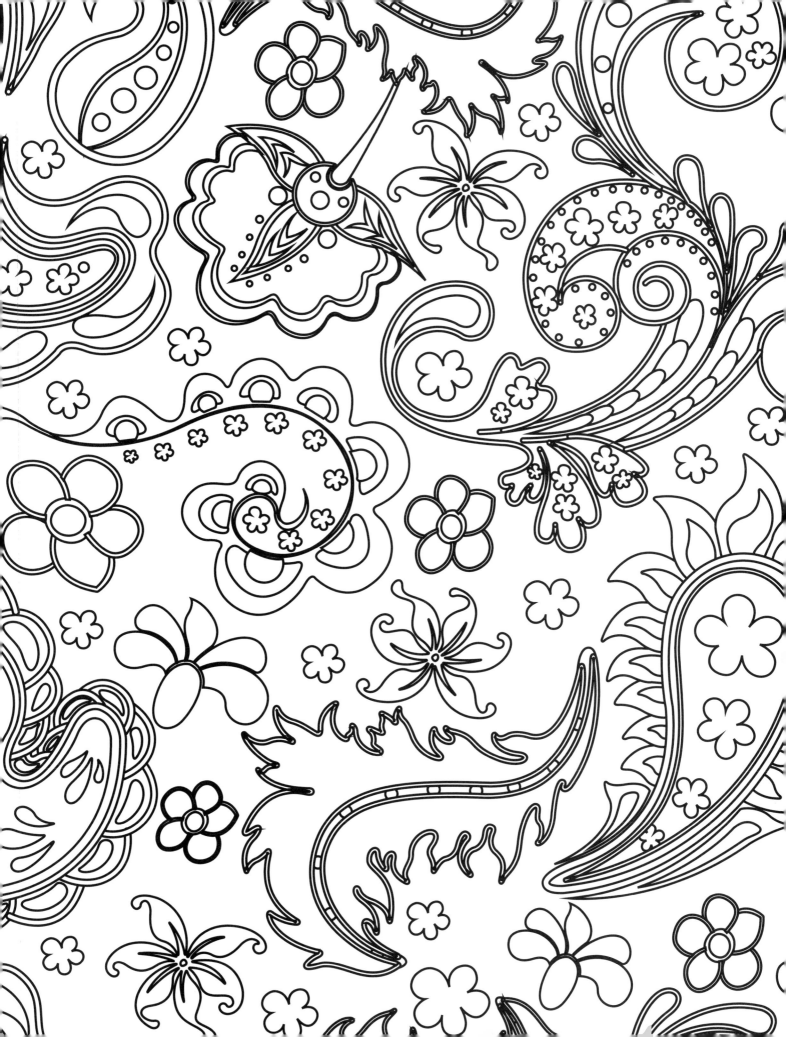

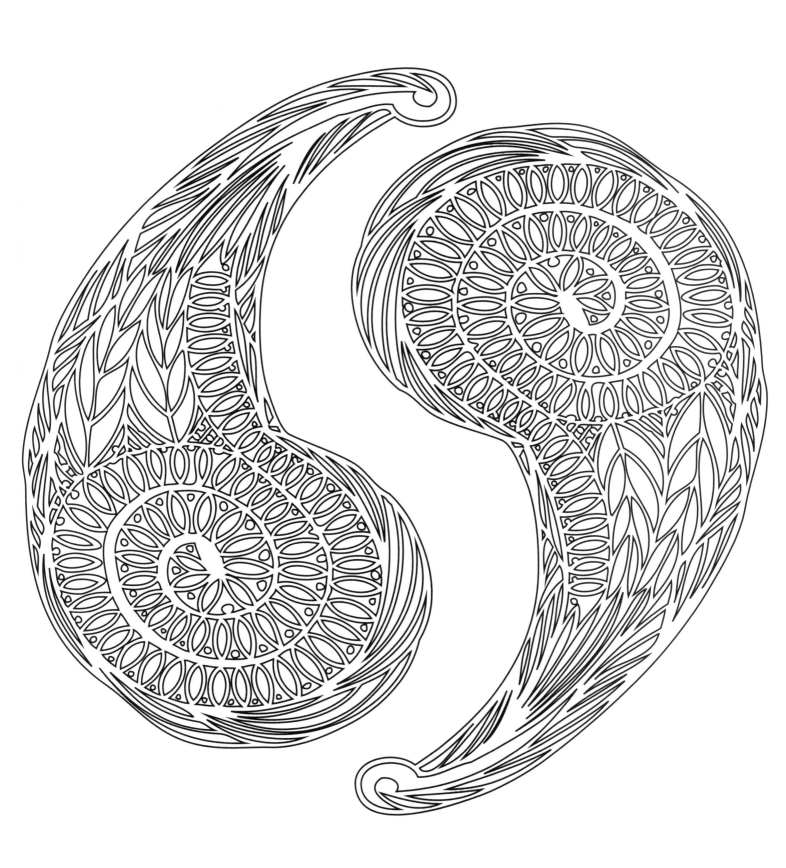

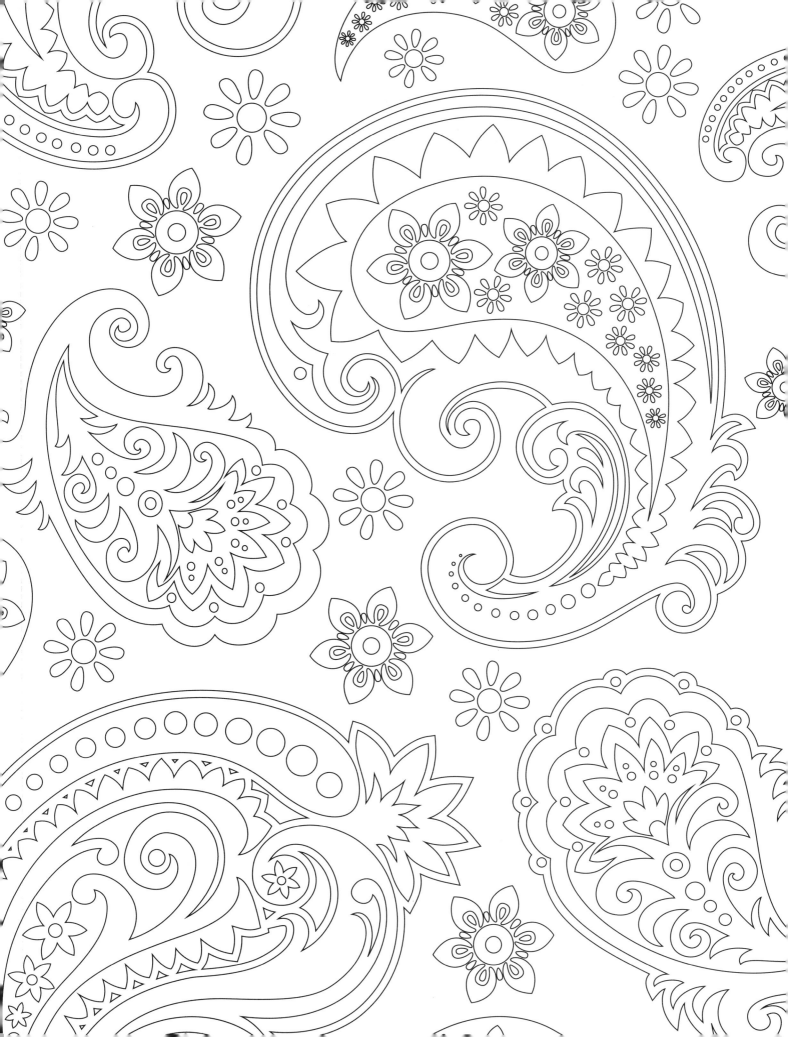

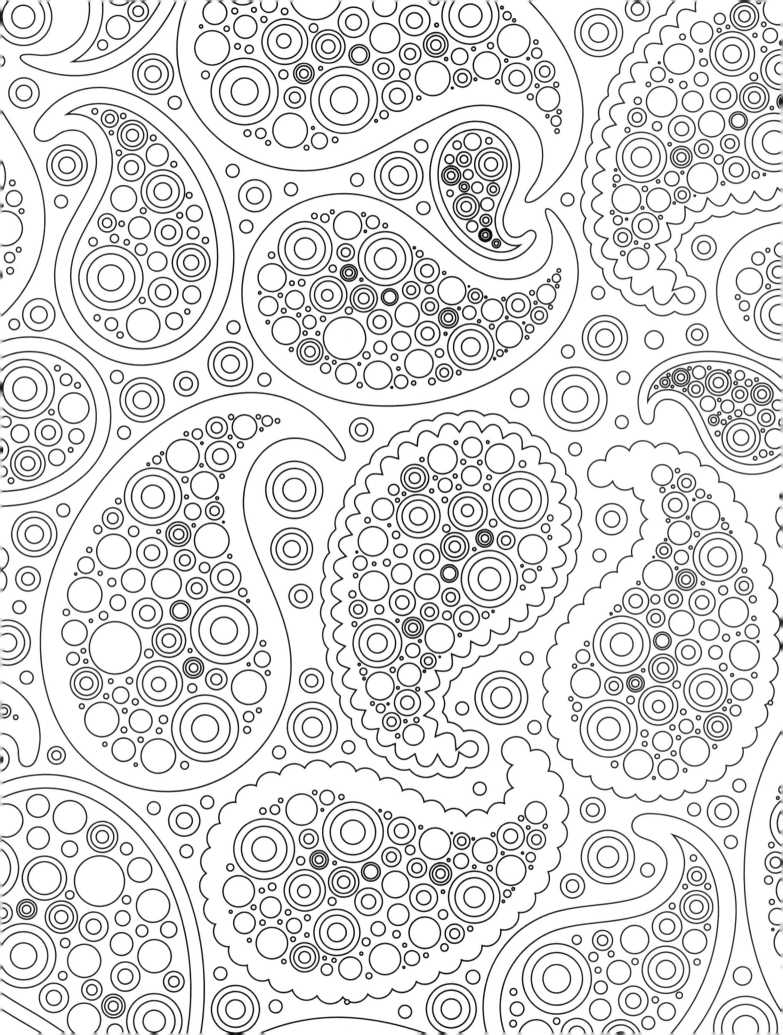

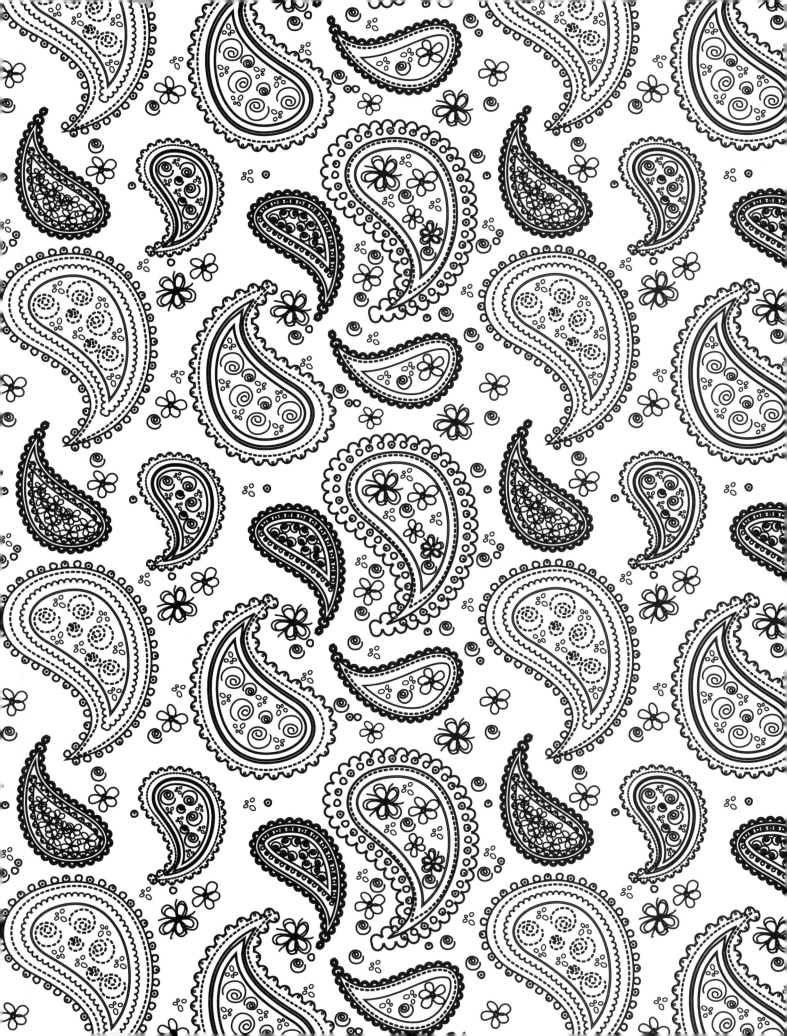

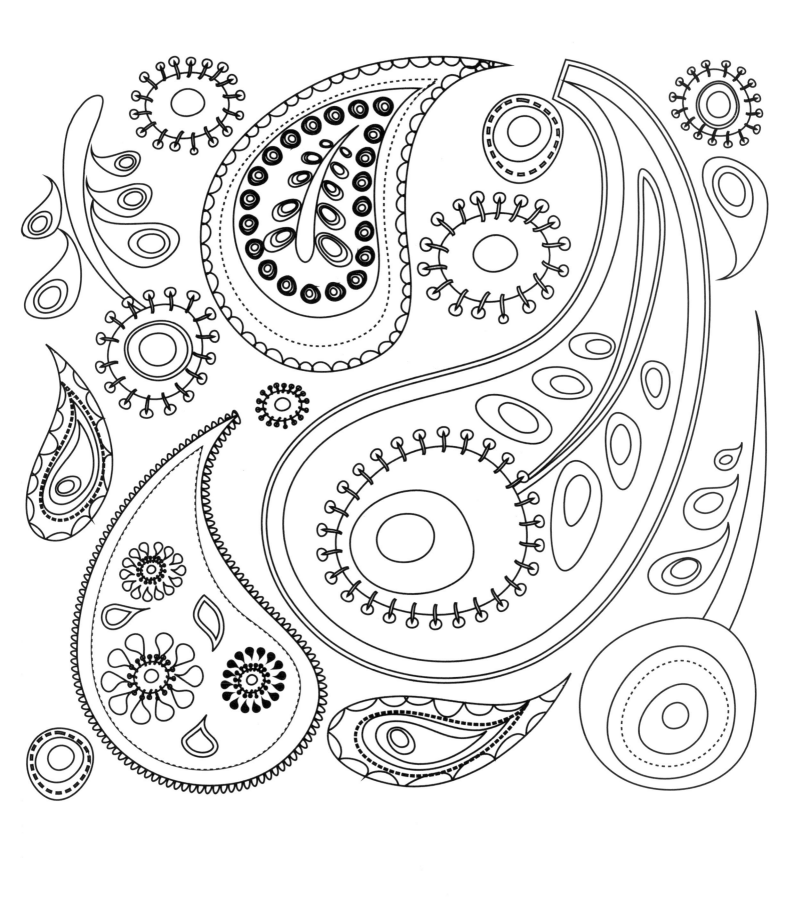

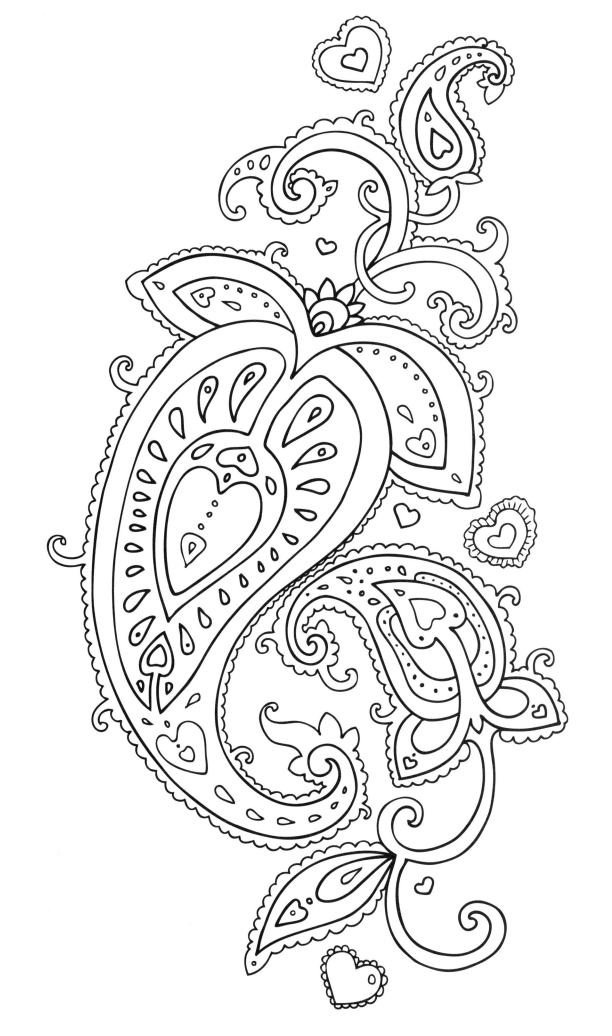

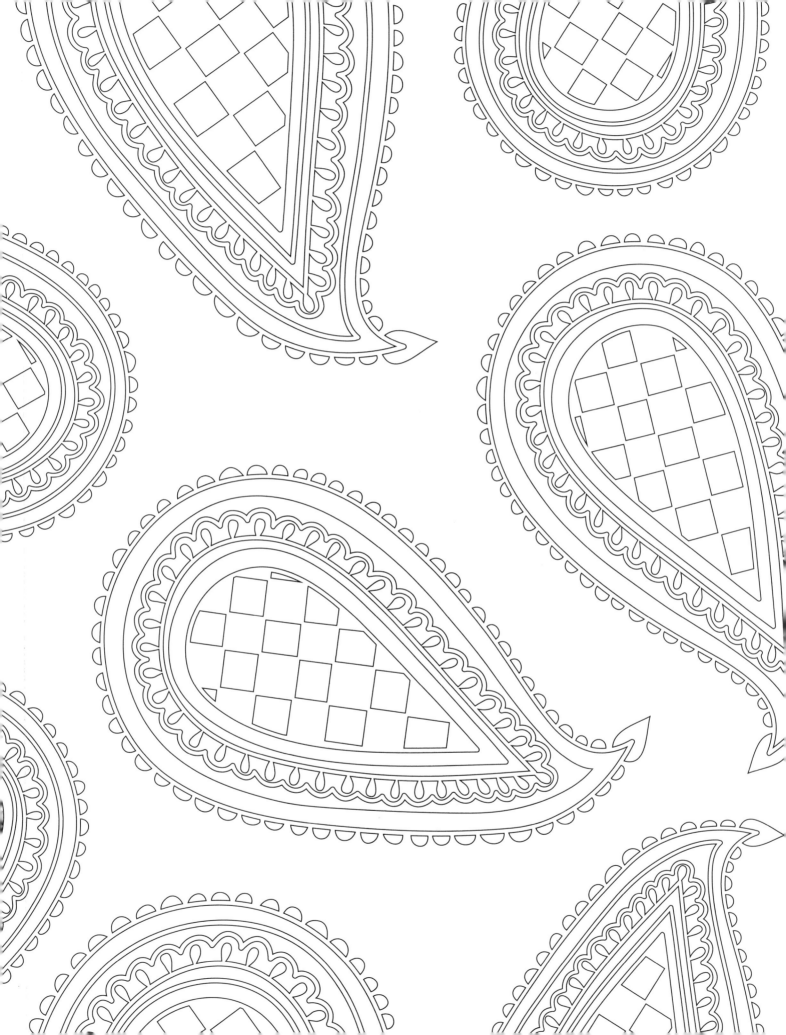

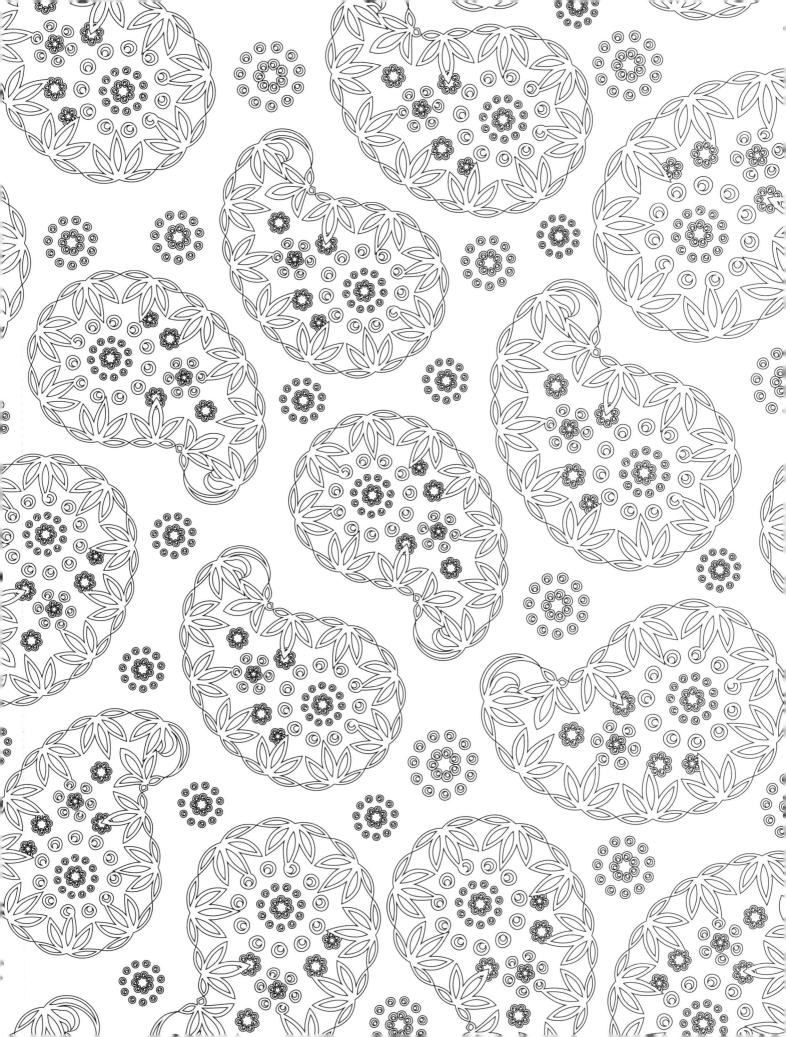

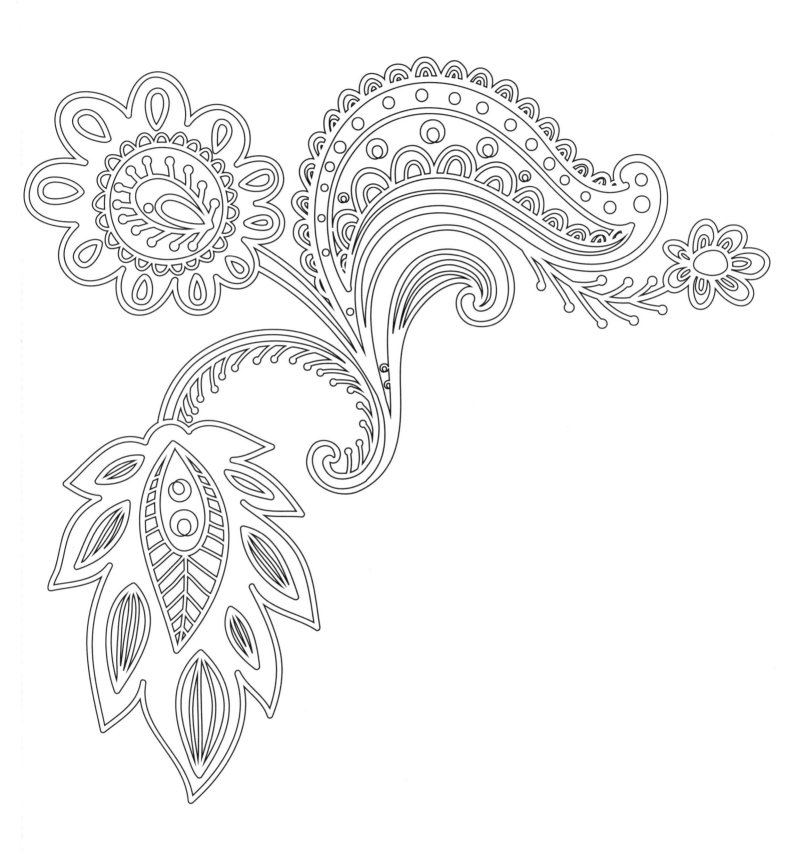

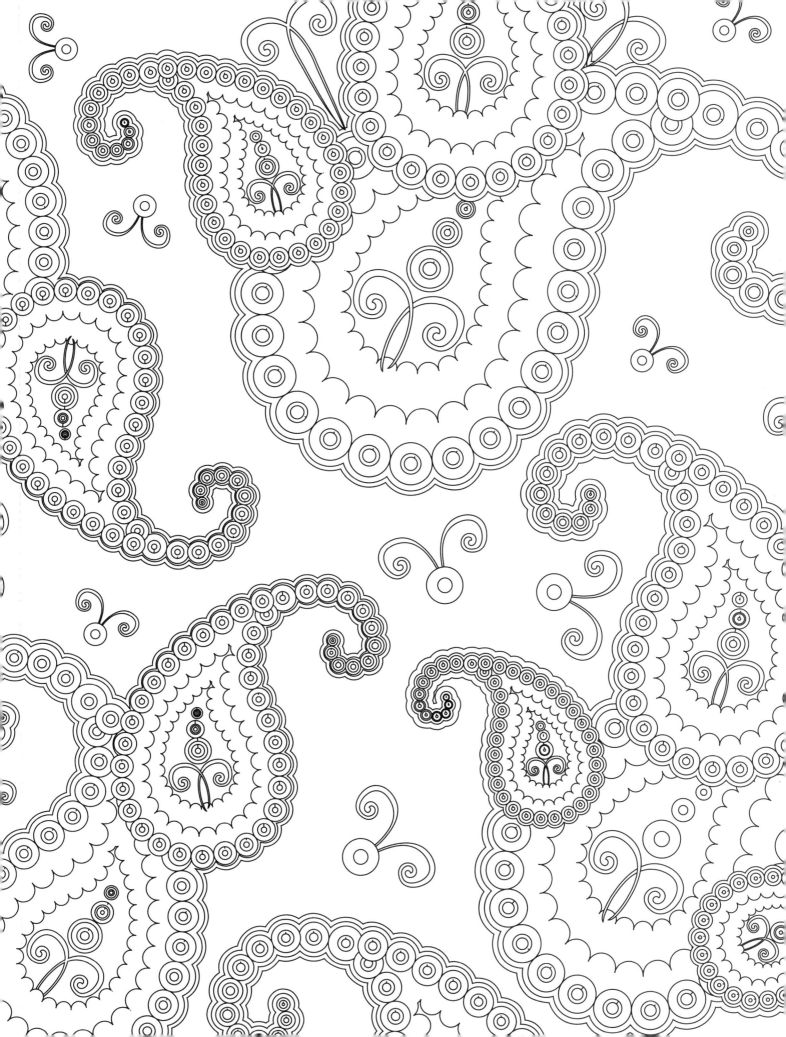

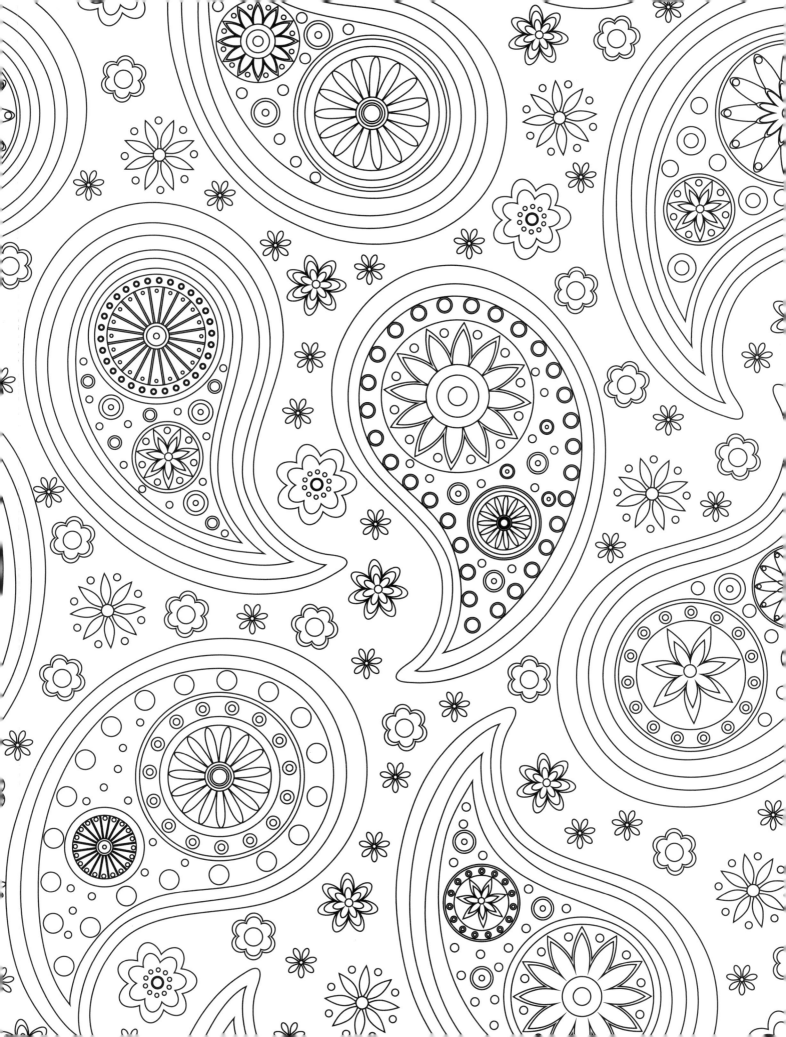

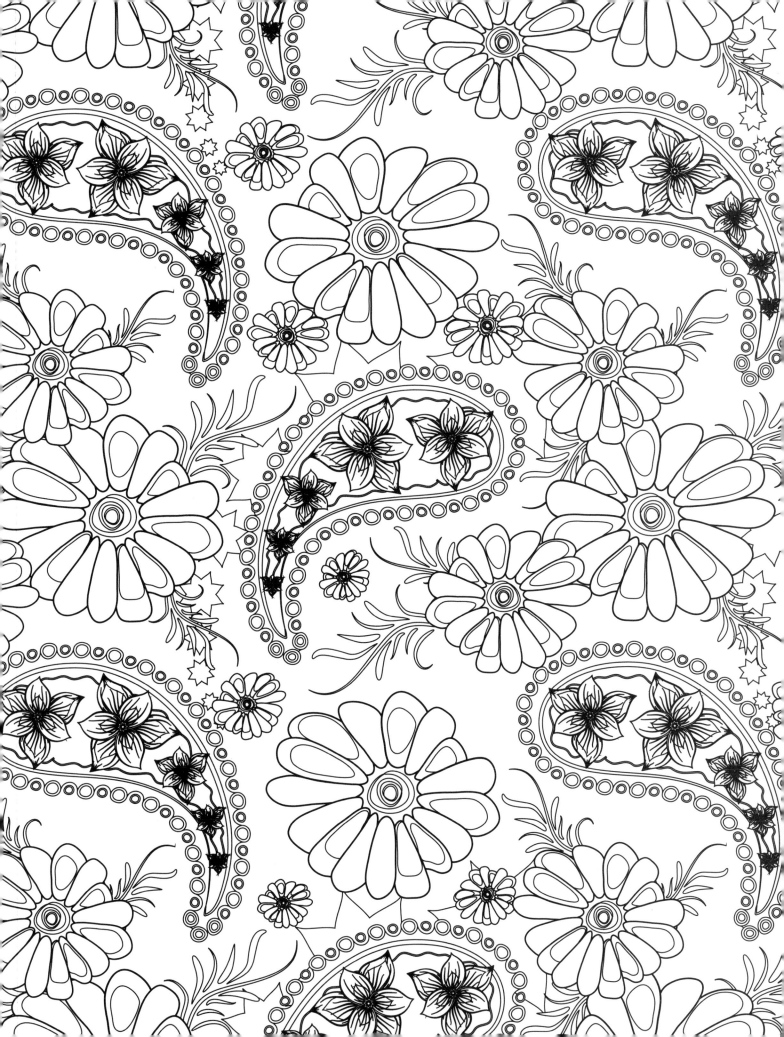

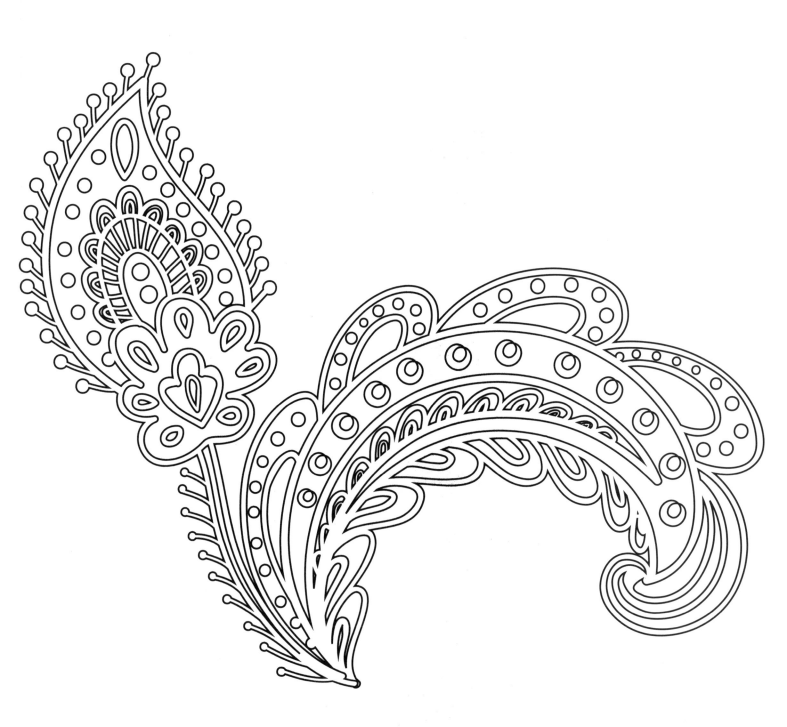

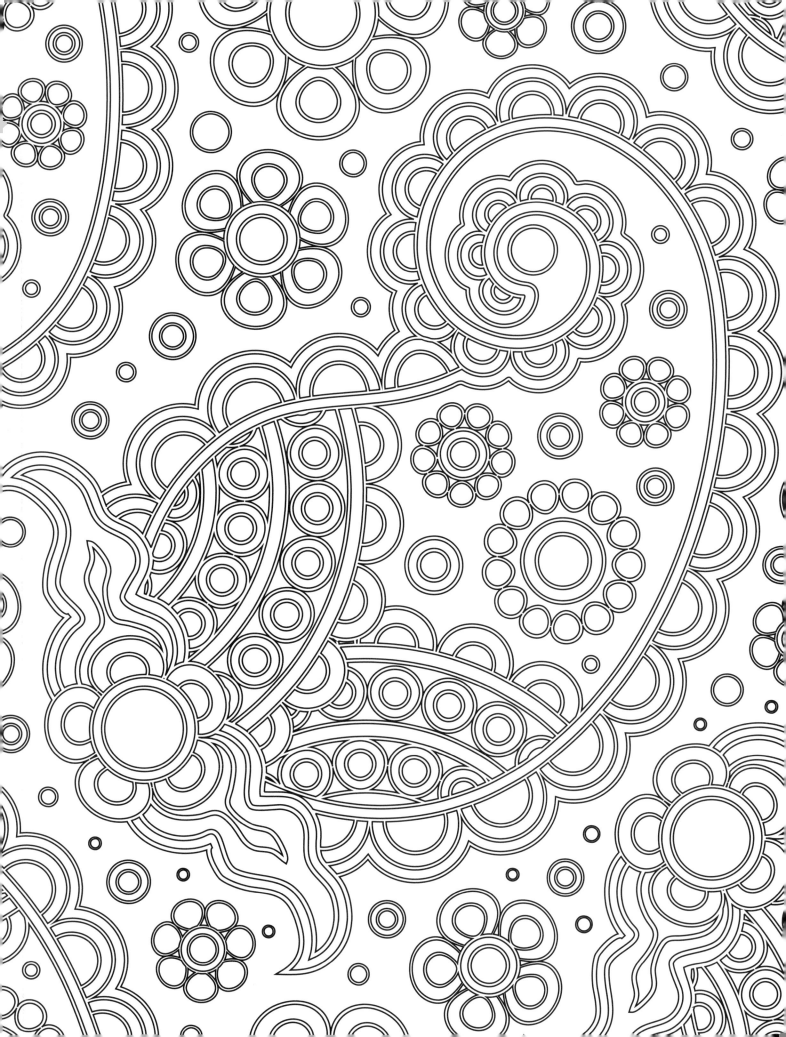

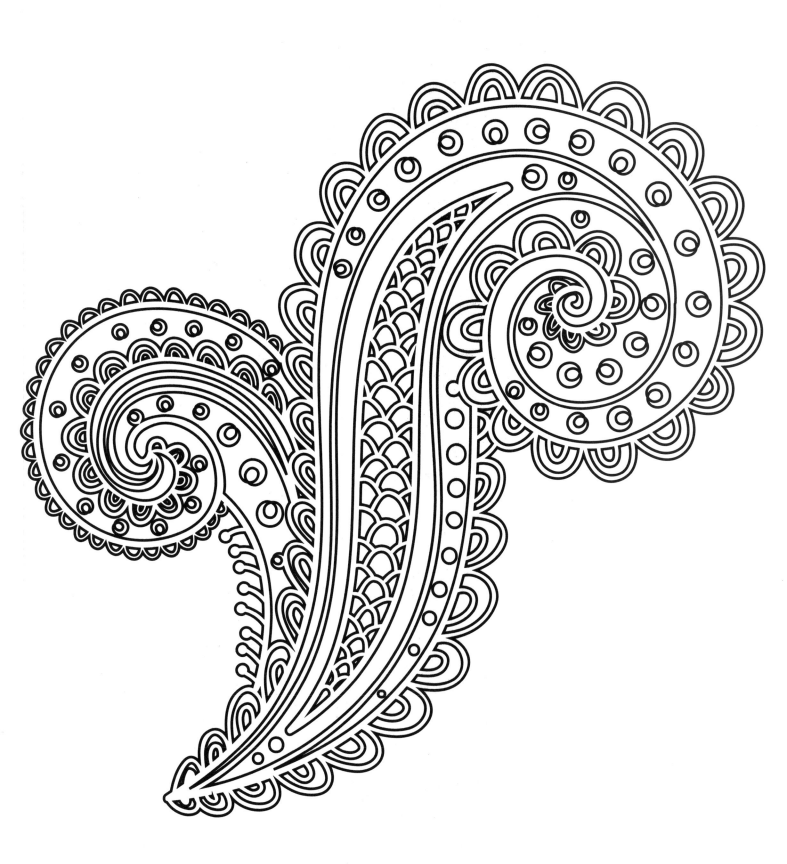

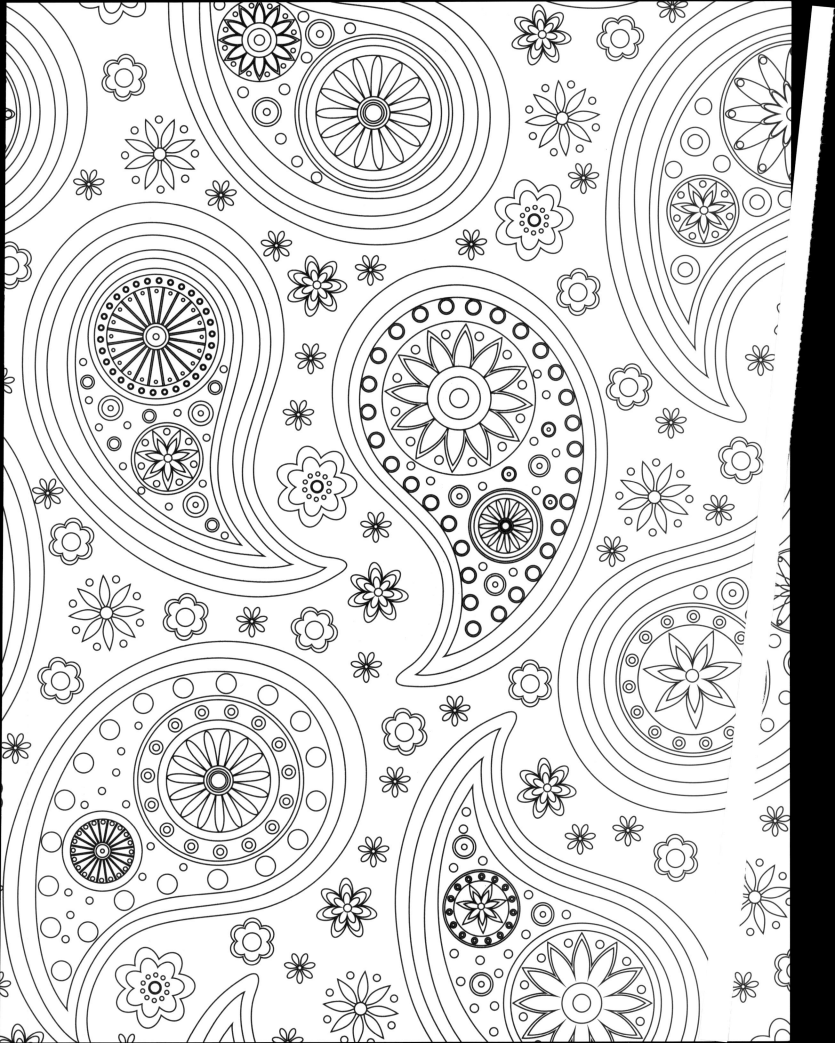

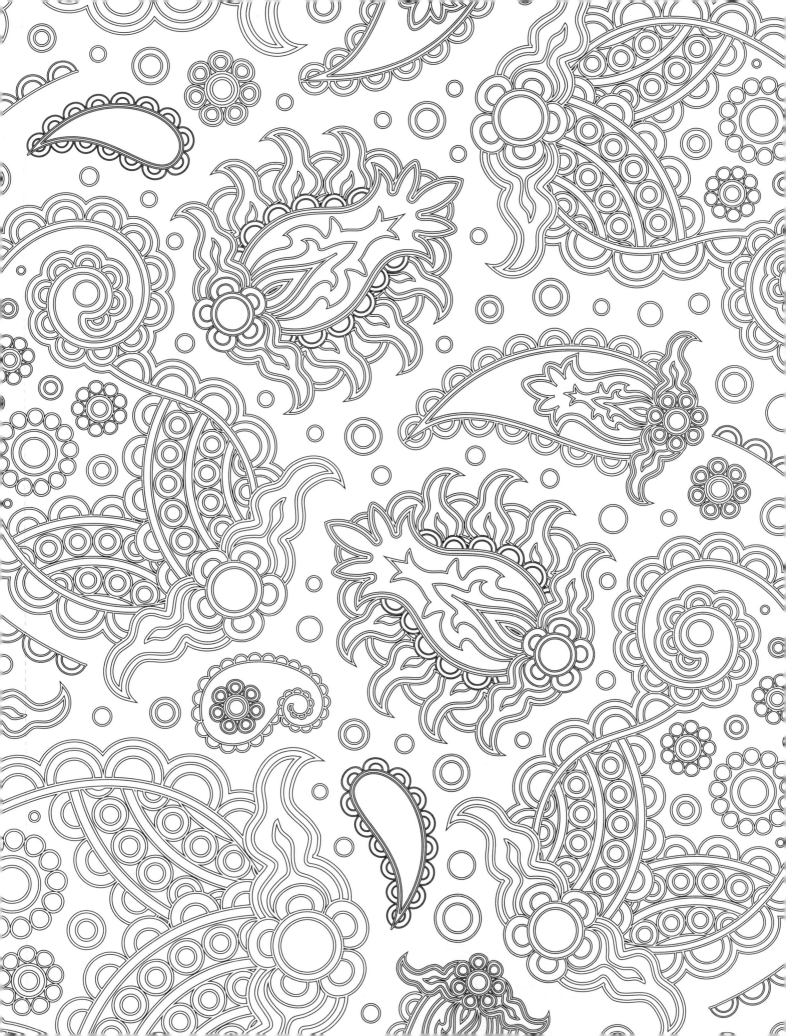

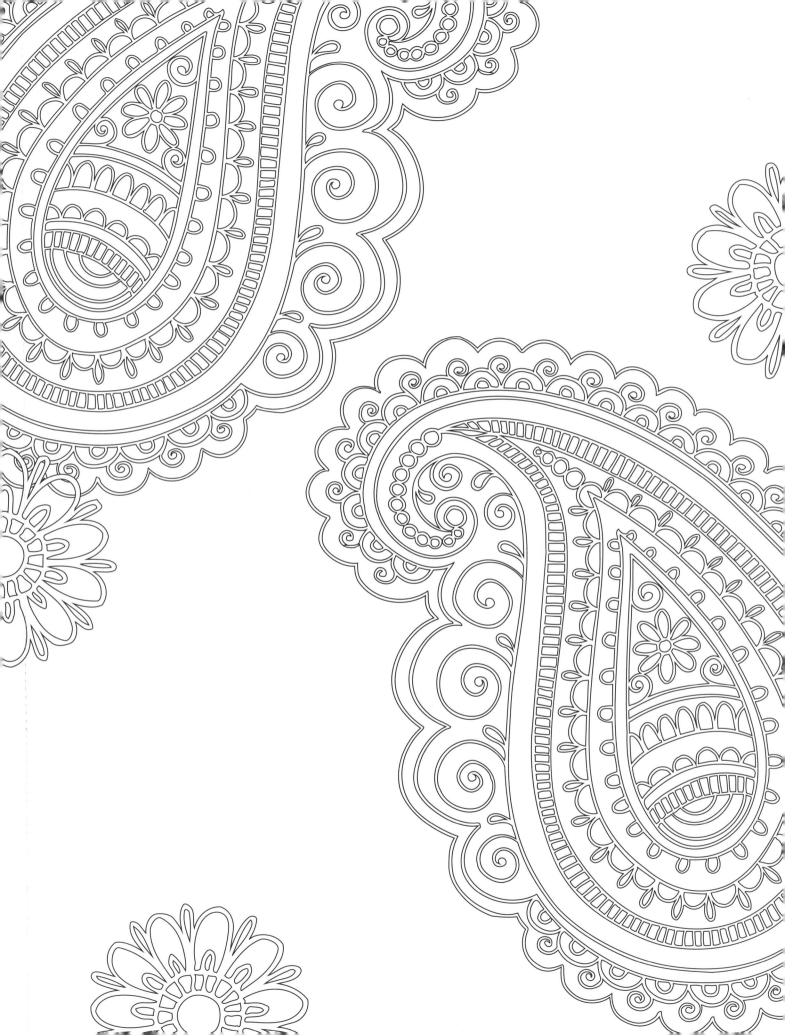

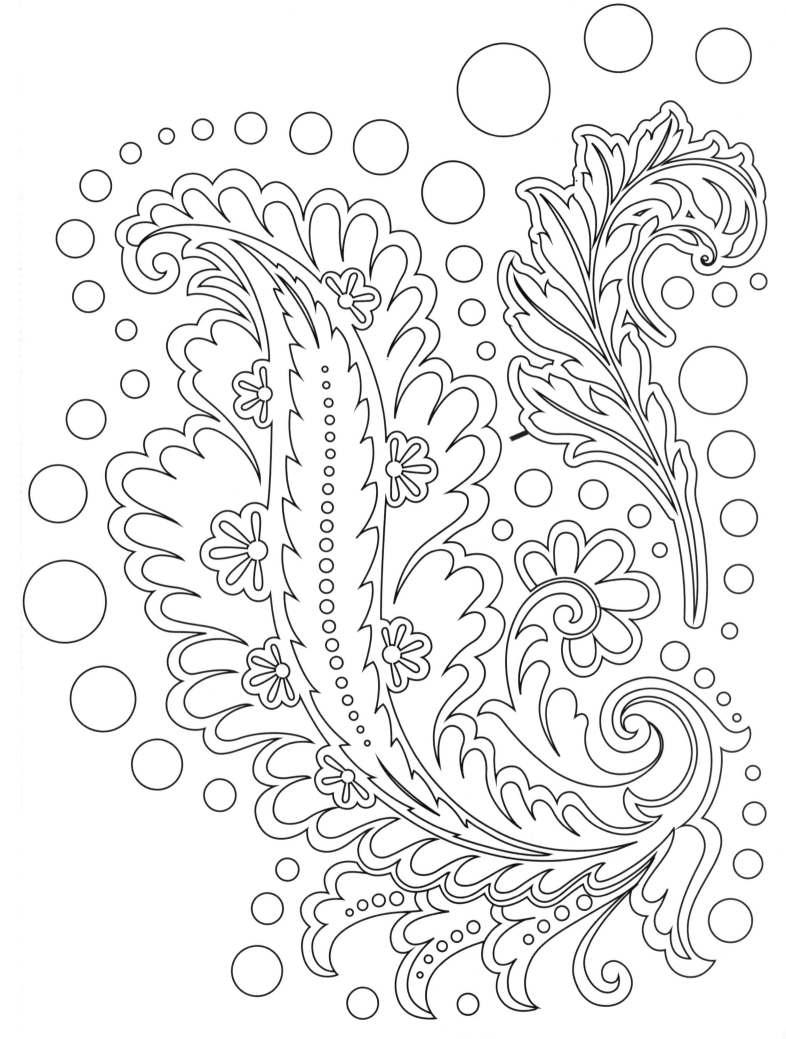

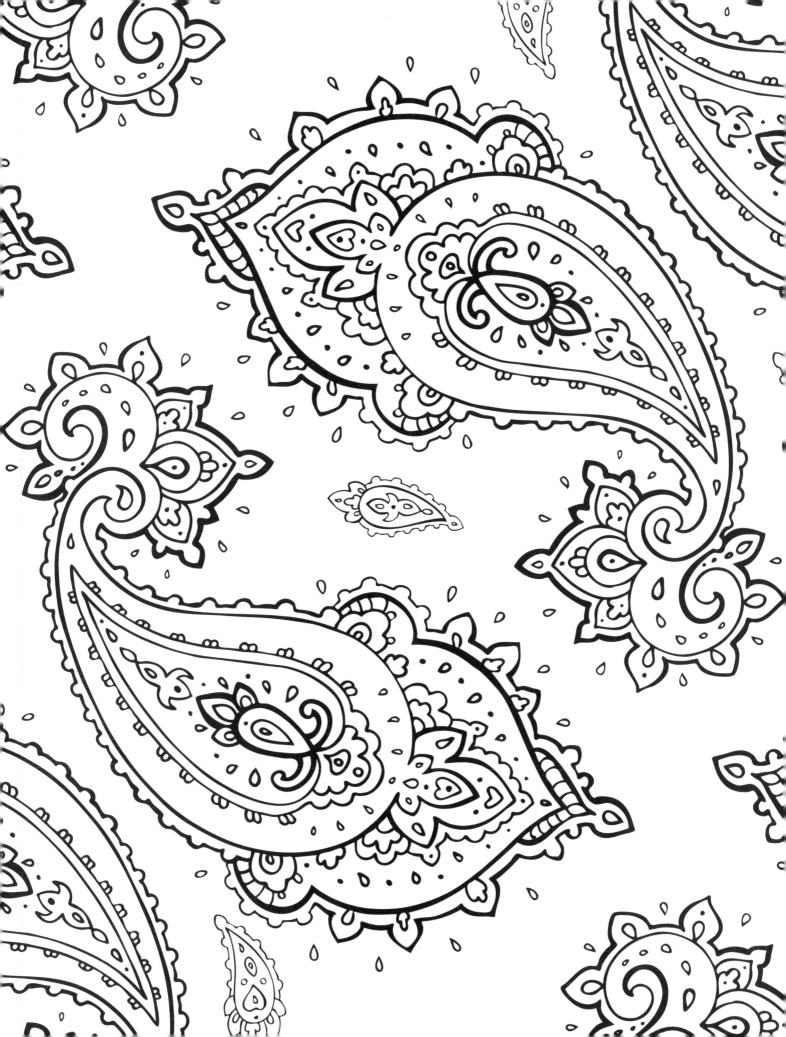

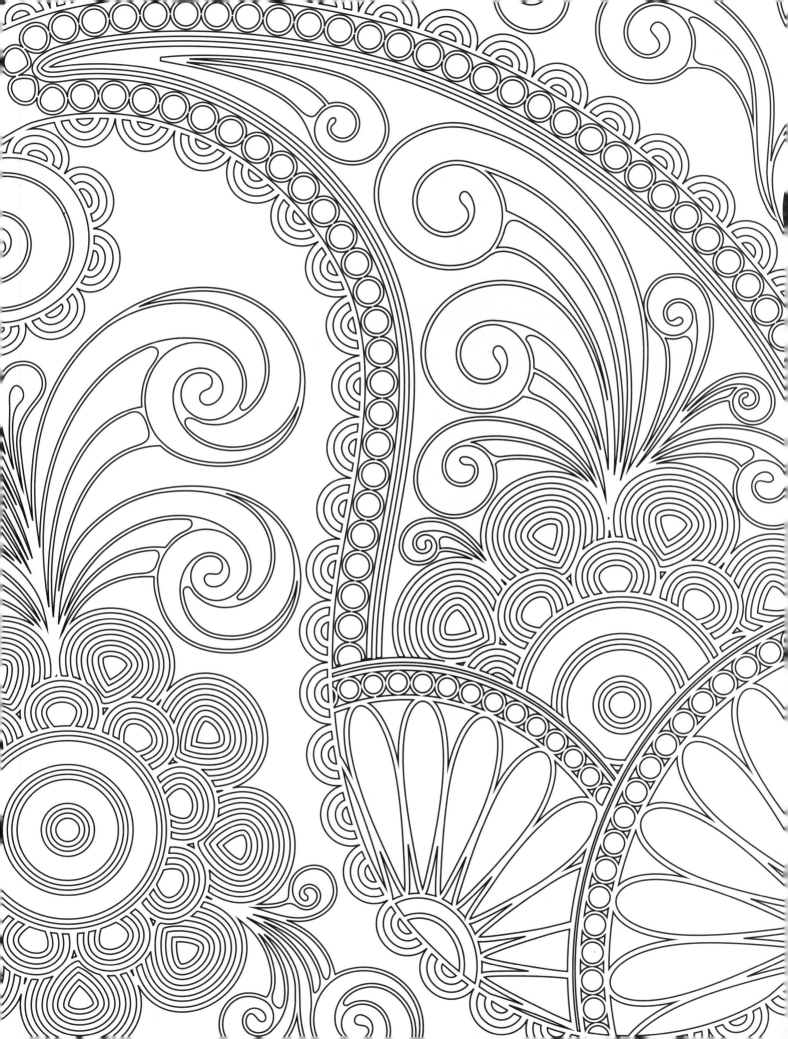

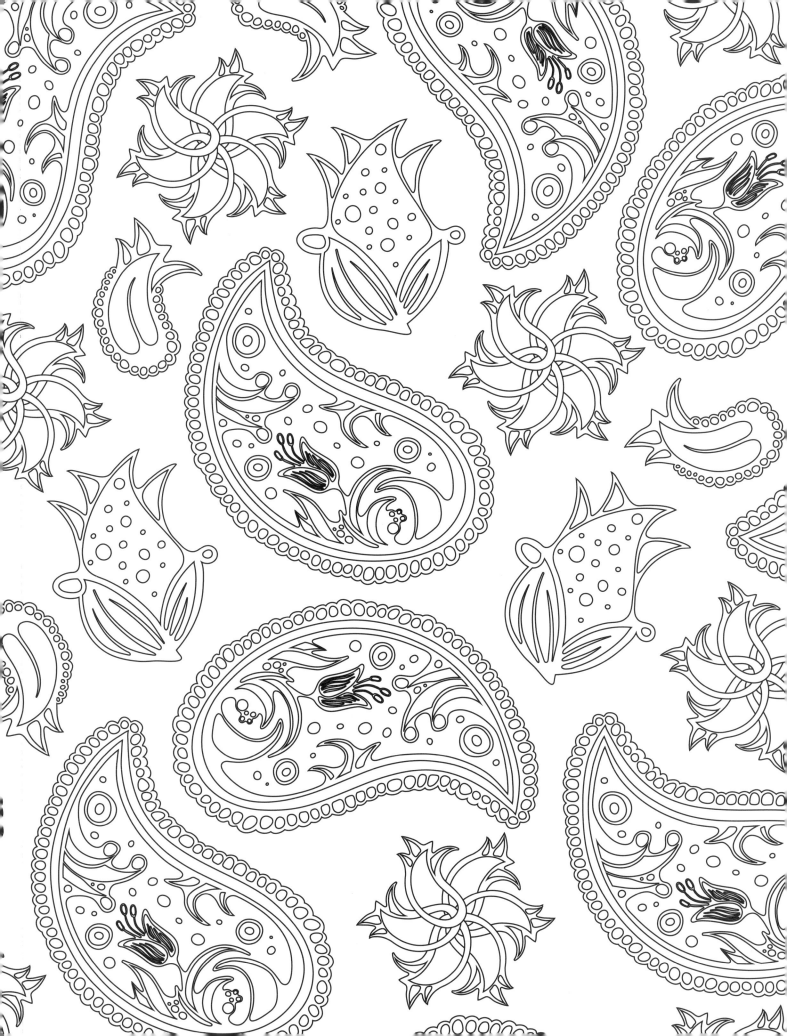

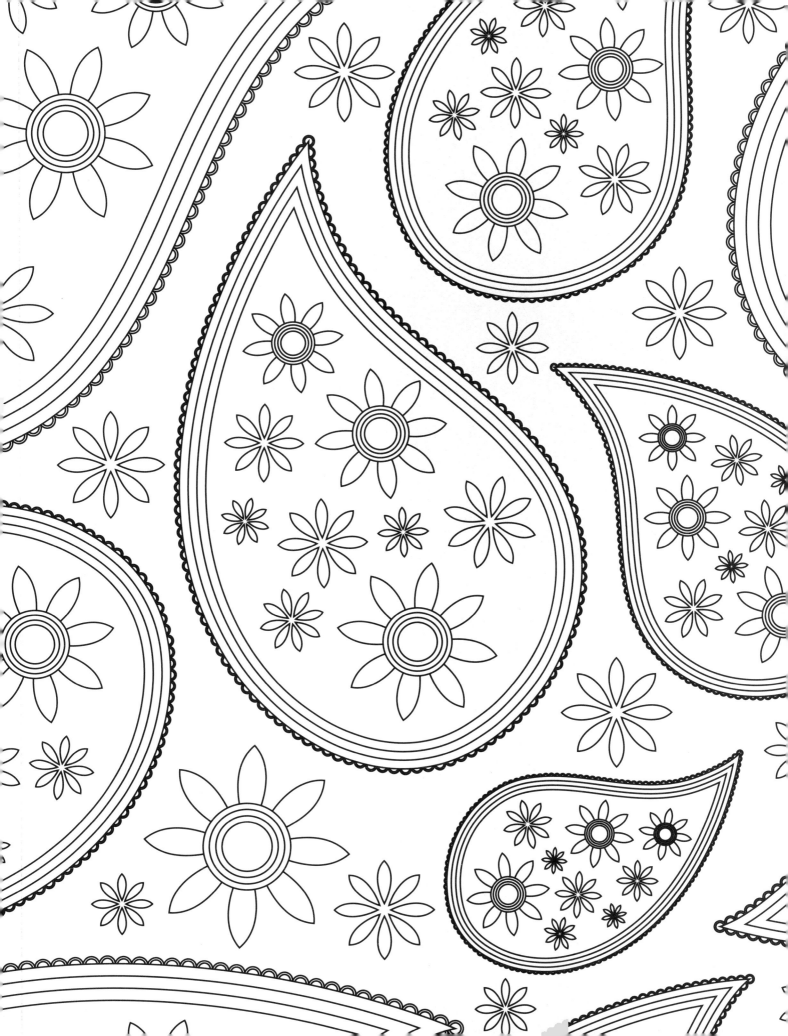

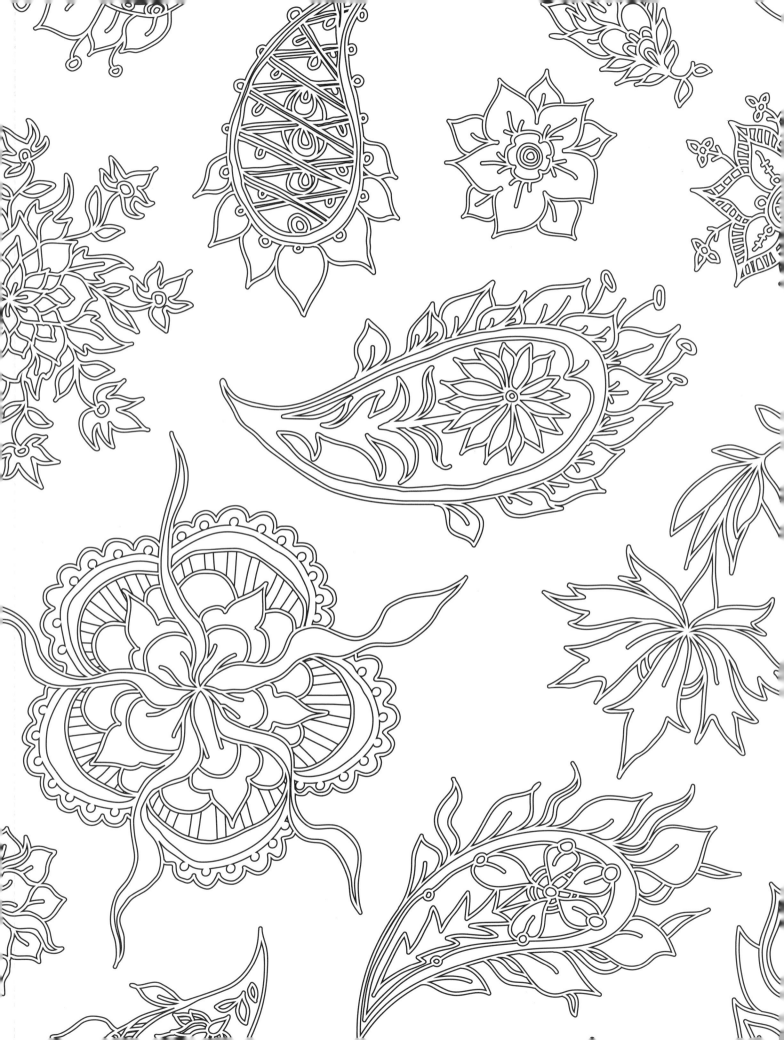

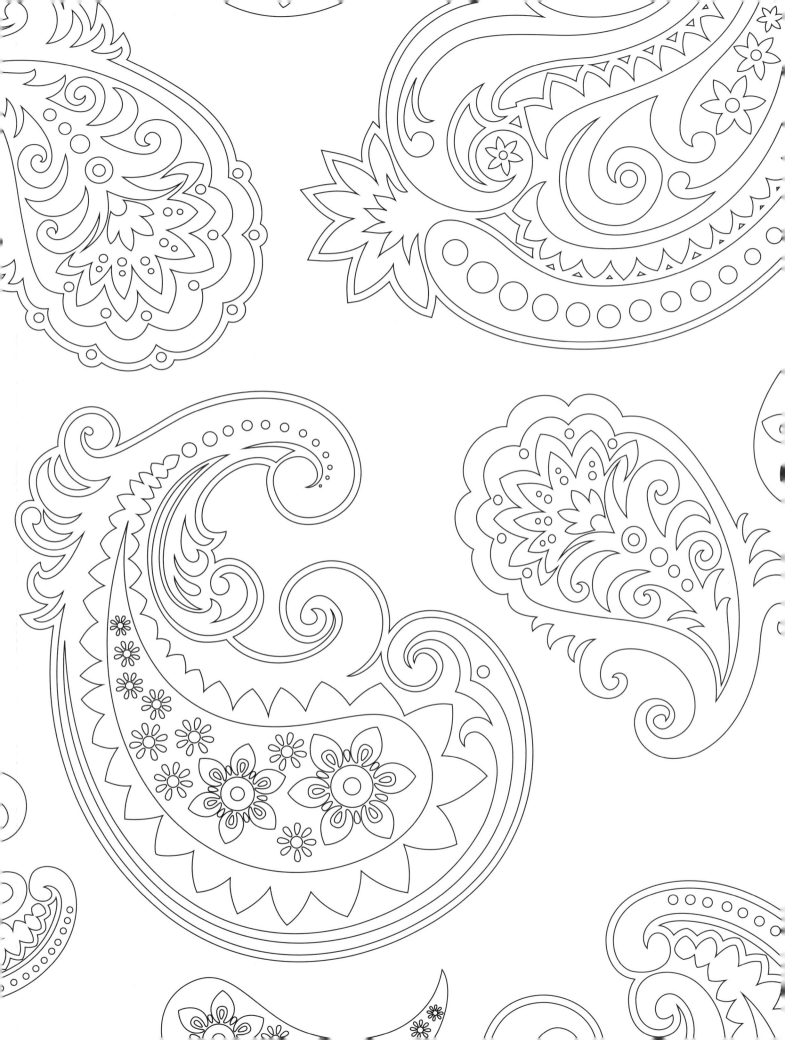

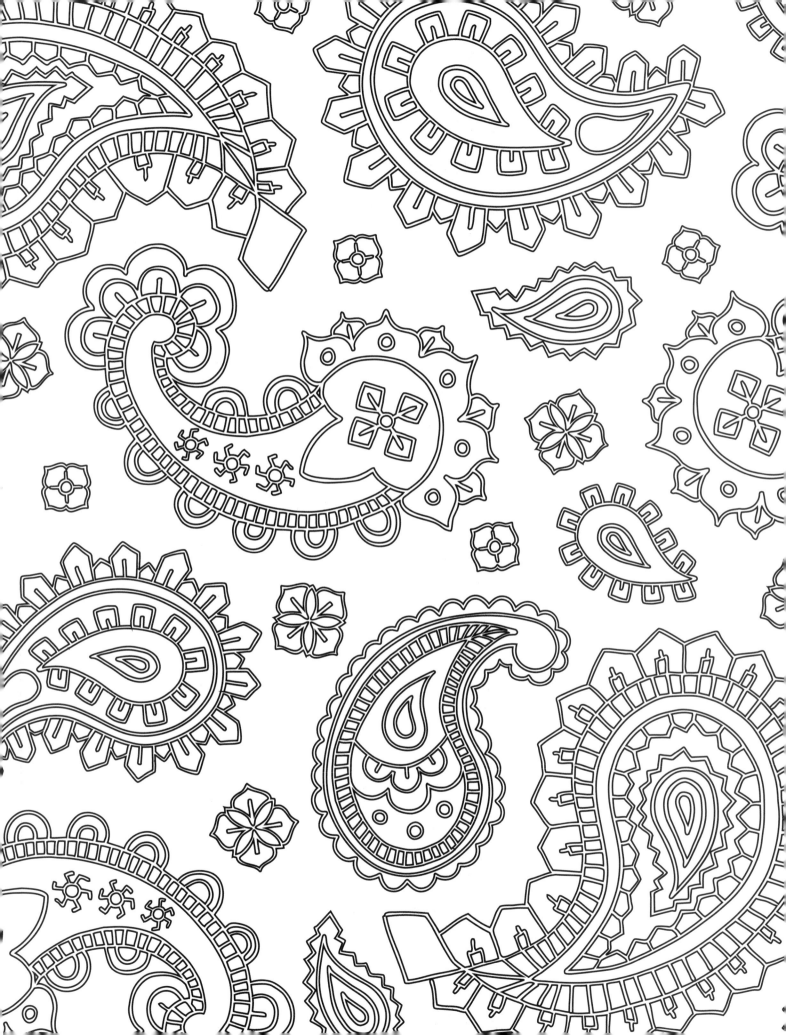

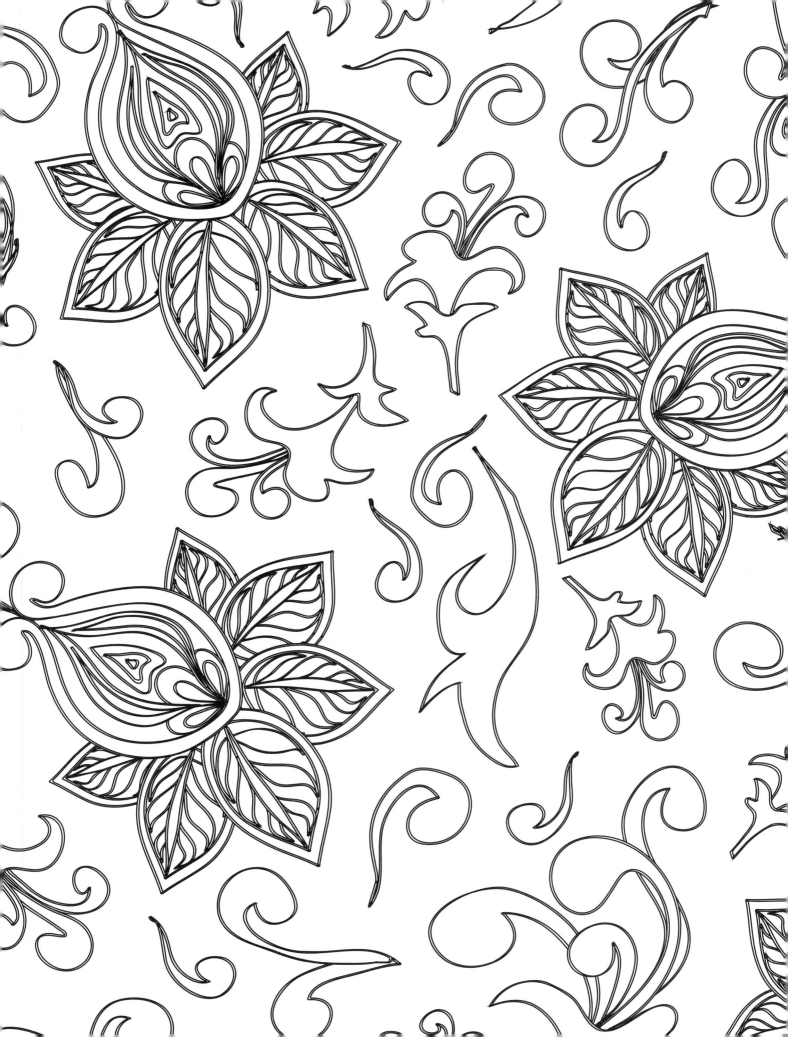

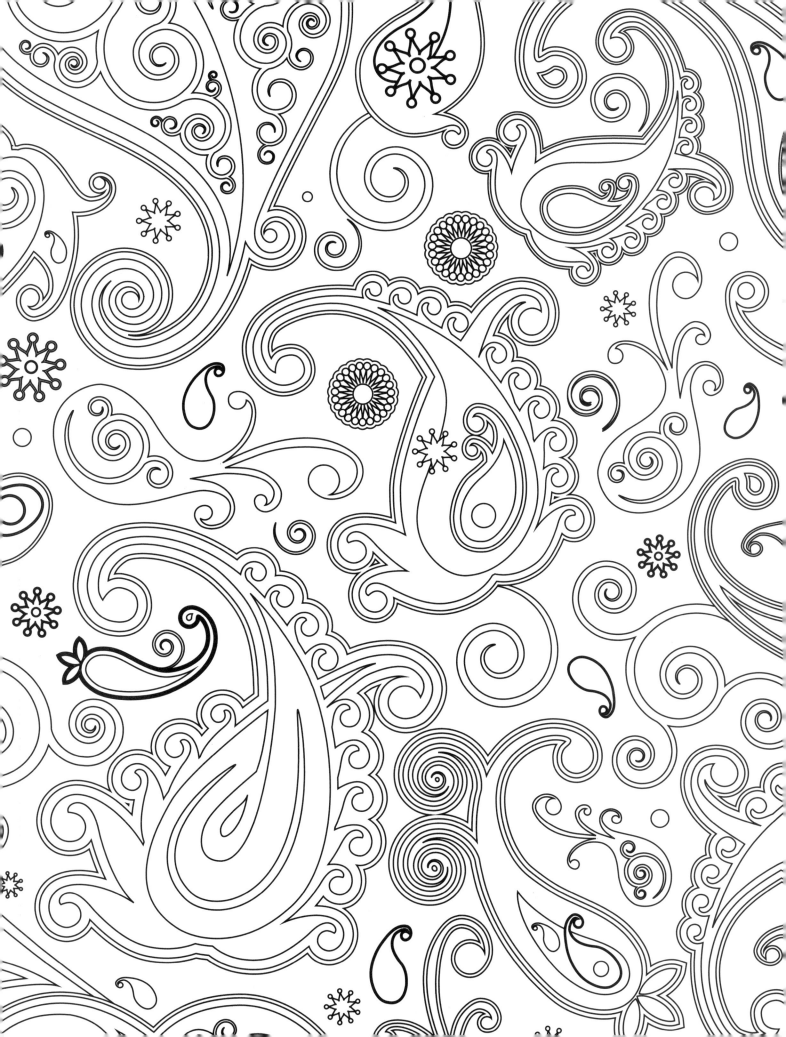

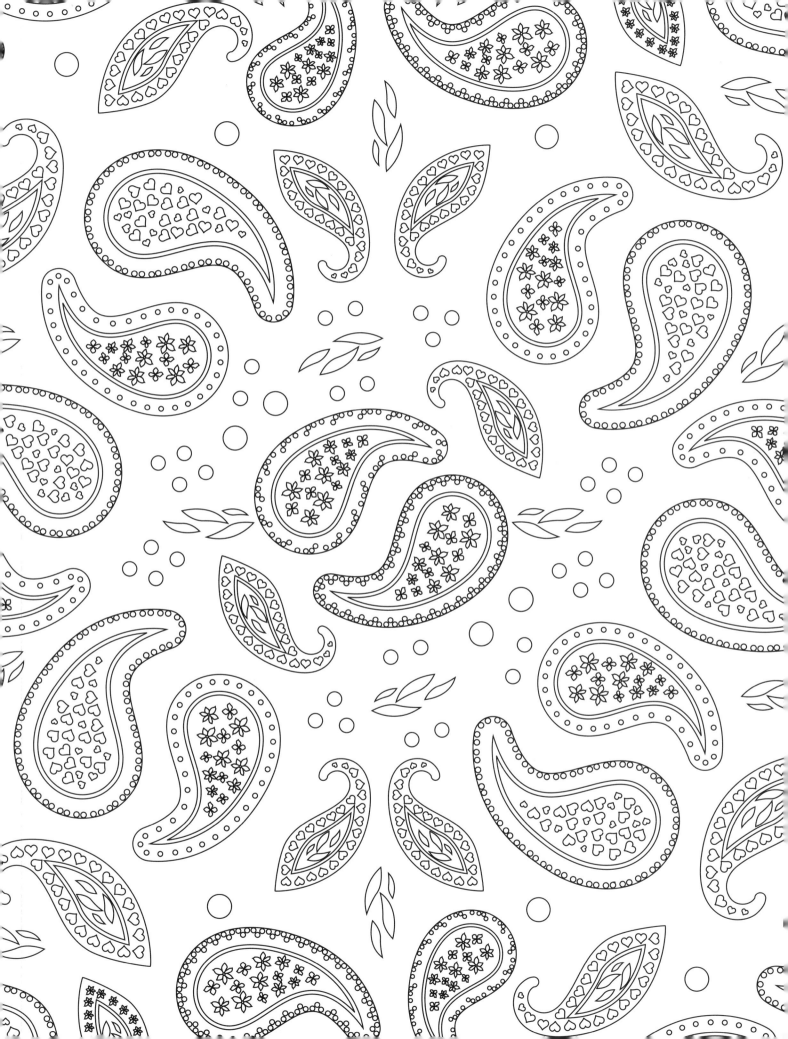

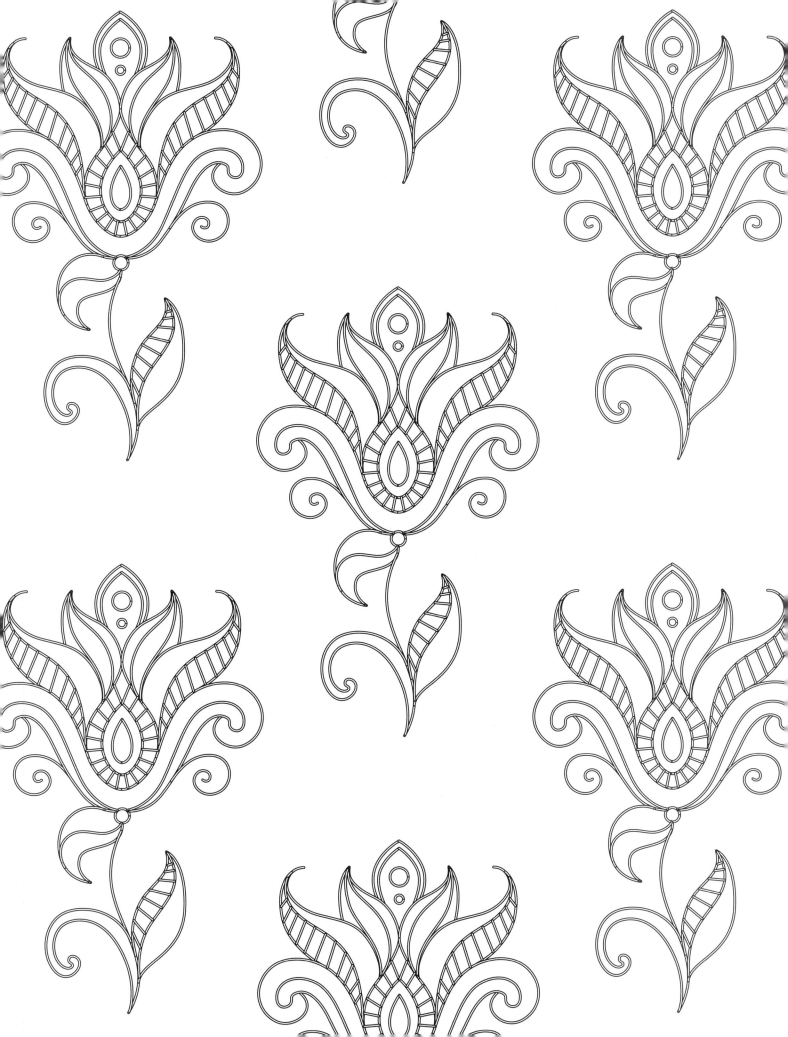

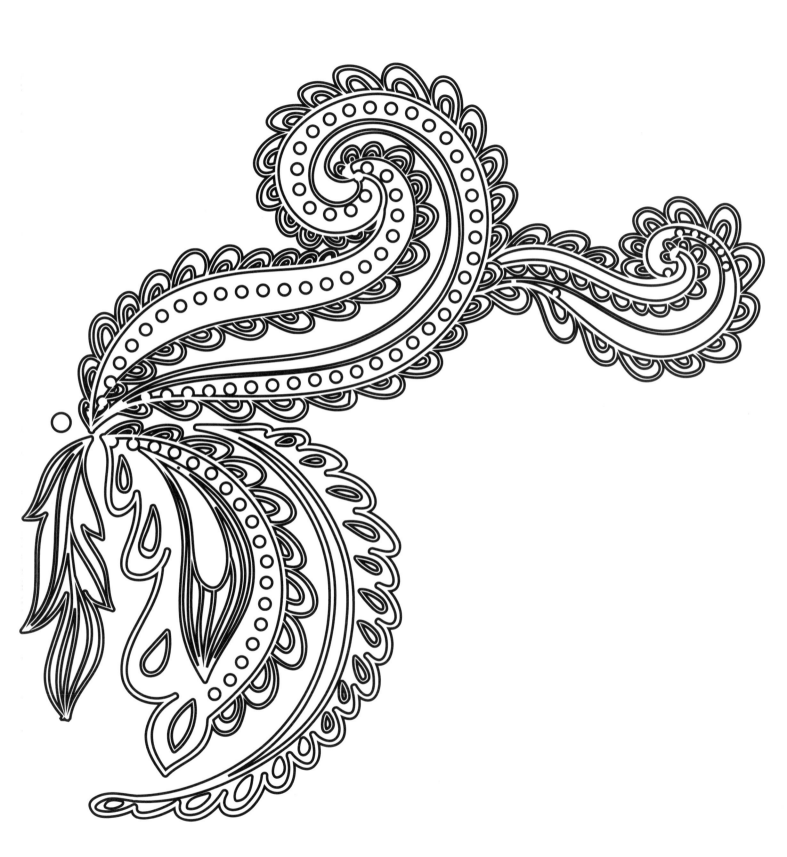

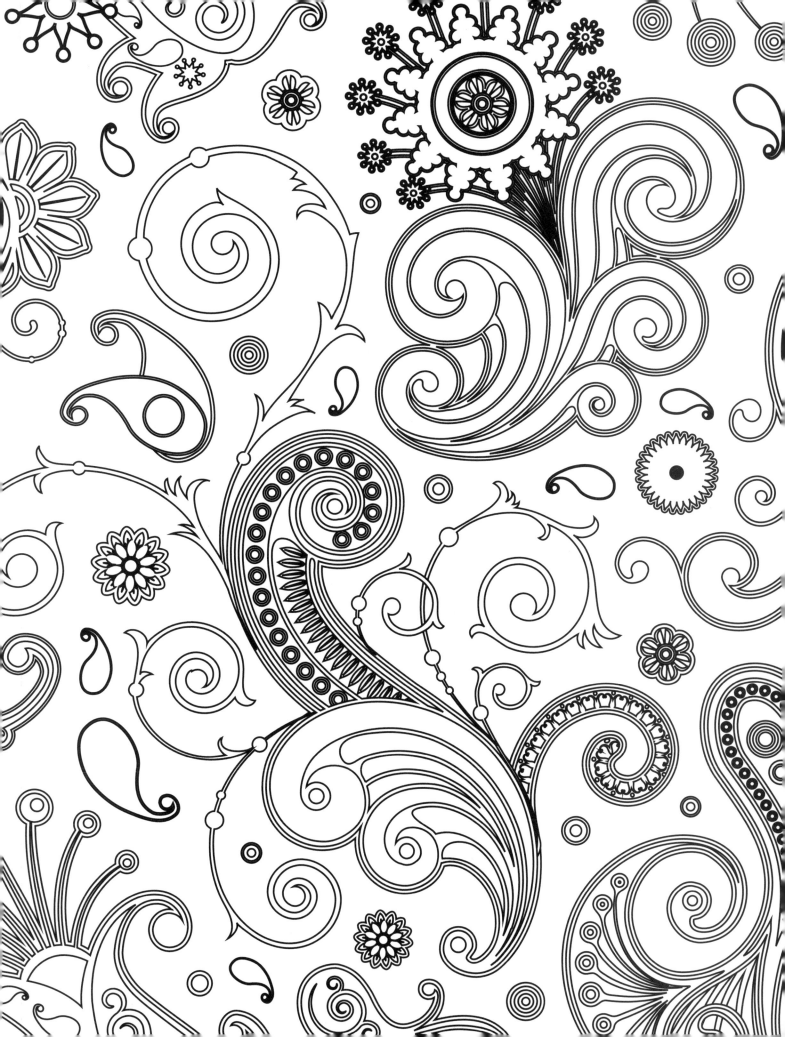

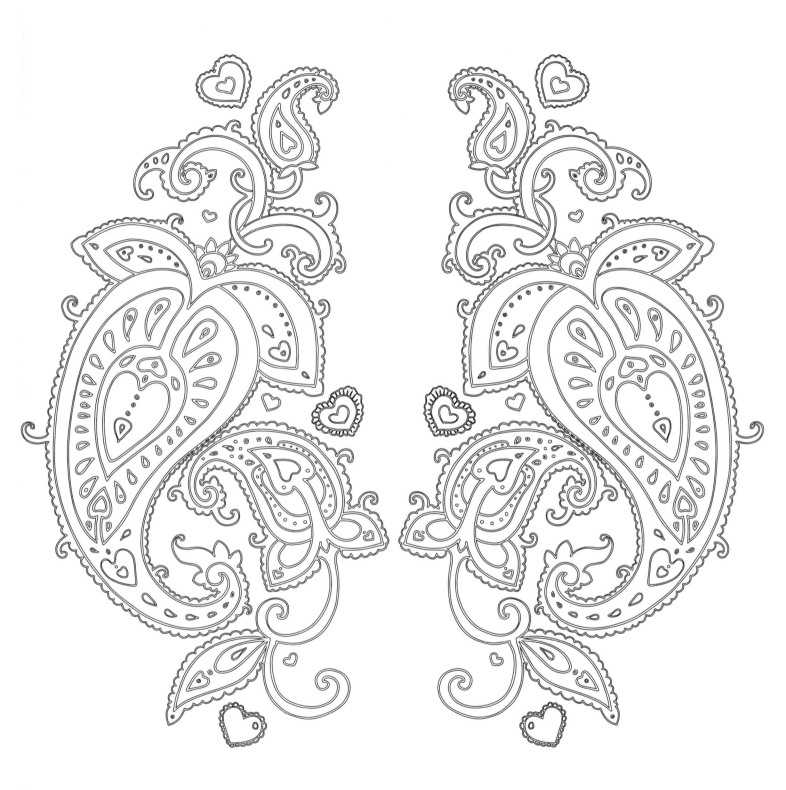

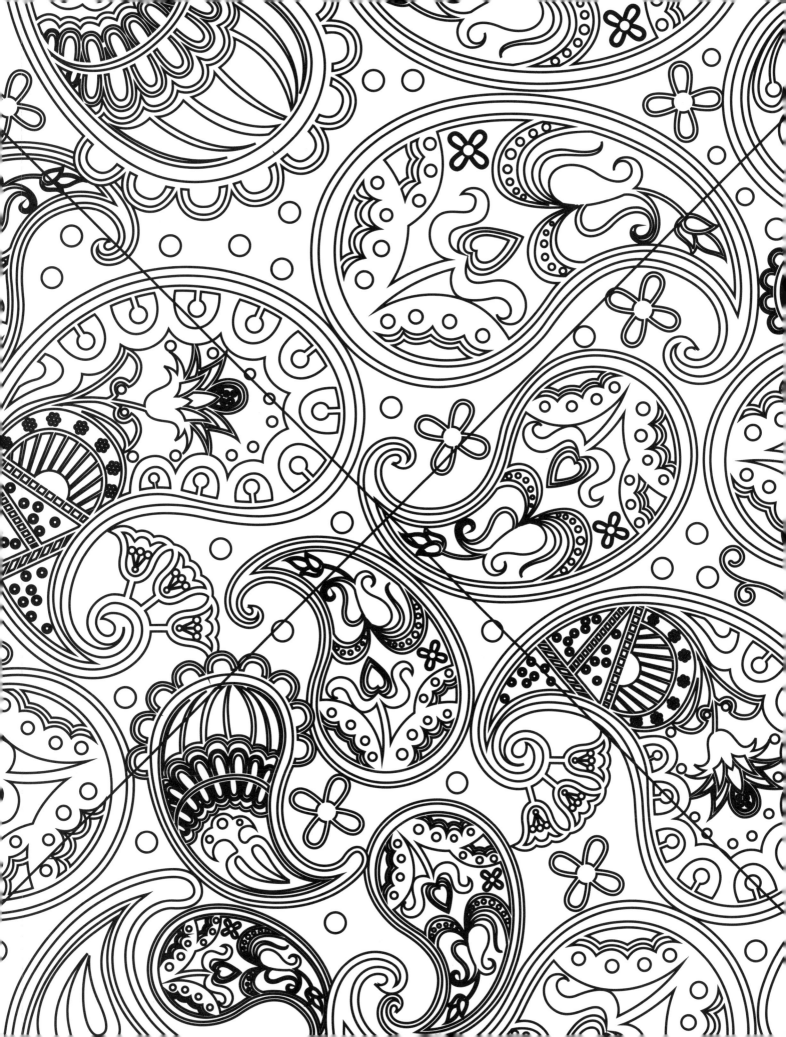

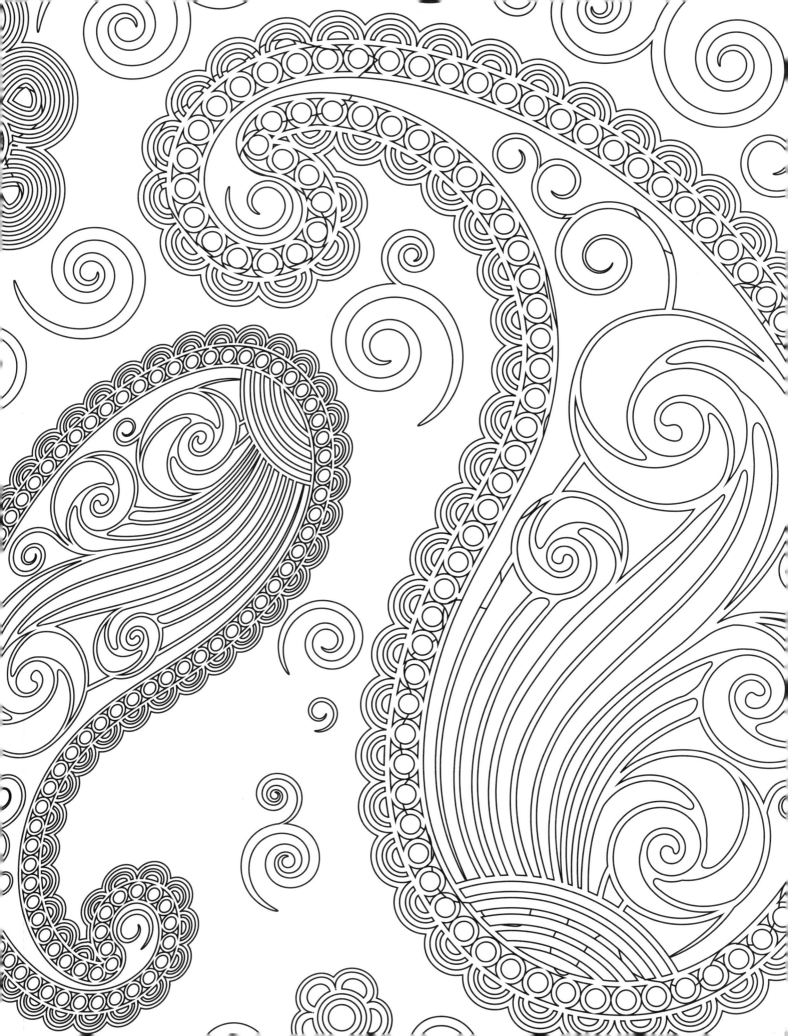

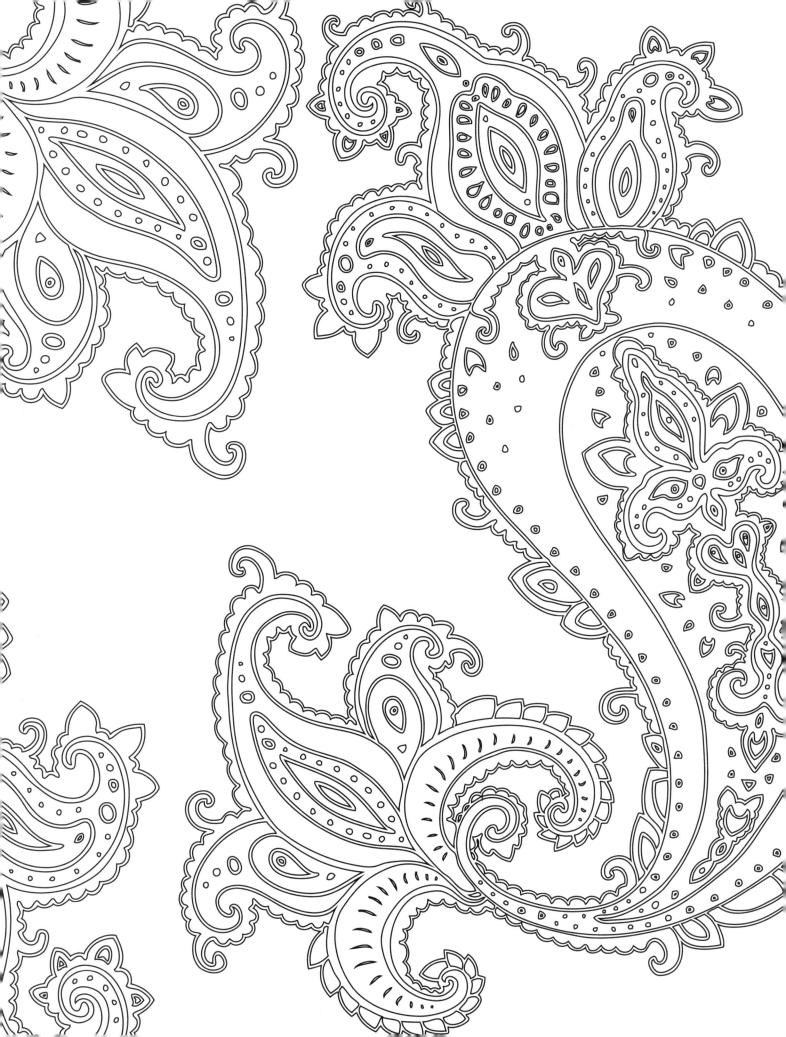

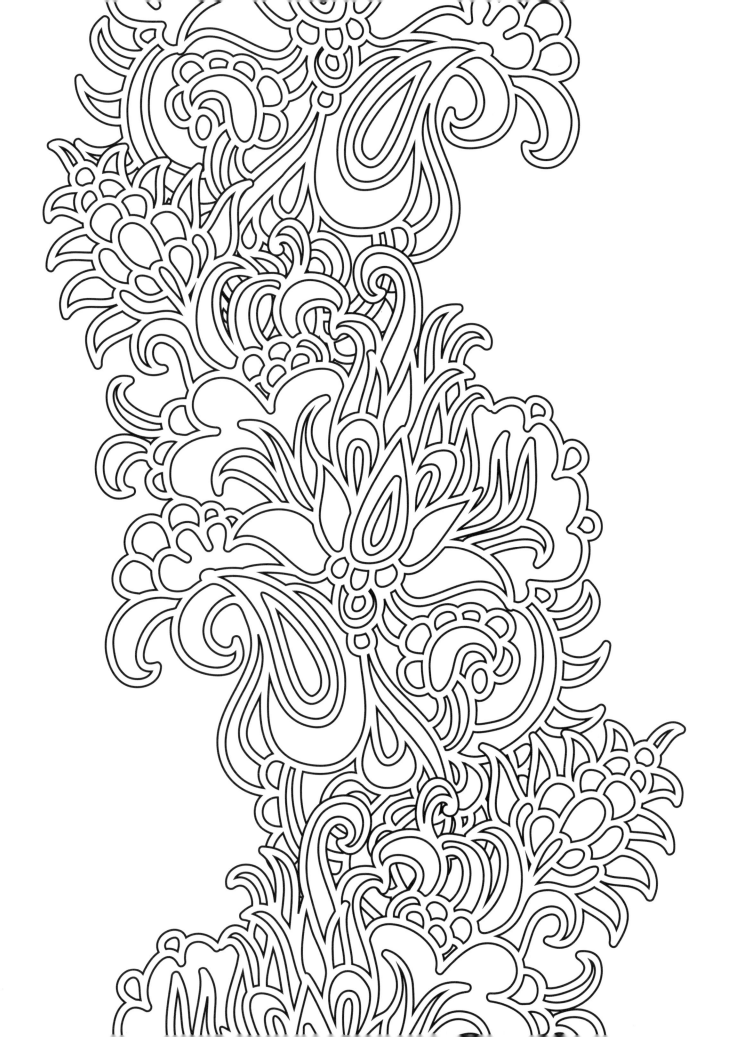

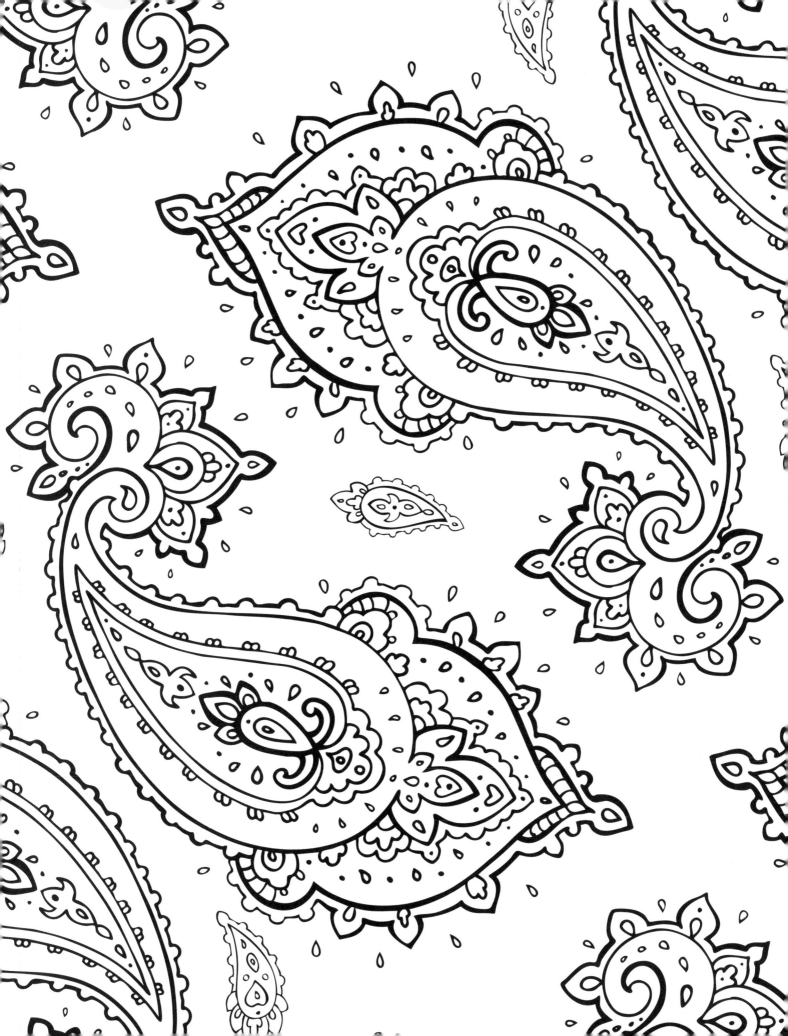

Color Bars

Use these bars to test your coloring medium and palette. Don't be afraid to try unique color combinations!

Color Bars

Color Bars

Color Bars